- A JAZZ AGE -
MURDER
IN NORTHWEST INDIANA

A JAZZ AGE
MURDER
IN NORTHWEST INDIANA

THE TRAGIC BETRAYAL OF NETTIE DIAMOND

JANE SIMON AMMESON

THE
History
PRESS

Published by The History Press
Charleston, SC 29403
www.historypress.net

First published 2015

Manufactured in the United States

ISBN 978.1.62619.478.6

Library of Congress Control Number: 2015935121

Notice: The information in this book is true and complete to the best of our knowledge. It is offered without guarantee on the part of the author or The History Press. The author and The History Press disclaim all liability in connection with the use of this book.

CONTENTS

given to
Ginny by
Jennifer,
Step-daughter, May 8, 20, 18

PREFACE

Mrs. Diamond Spurned "Judas" Kiss of Harry After He Shot Her
—*Lake County Times*, February 15, 1923

February 14, 1923, 11:00 a.m., East Chicago, a steel mill boomtown on Lake Michigan near the state line separating Chicago, Illinois, from Indiana.

Driving south on Melville Avenue toward Chicago Avenue on a cold and dreary Valentine's Day, Frank Simbolmos braked to a sudden stop as a Hudson sedan came roaring west down Chicago Avenue toward him. As the Hudson pulled sharply to the curb in front of Calumet Drug Store, Simbolmos thought he heard a gunshot. But he

Harry Diamond, a senior at Emerson High School, 1916. *Photo courtesy of the Calumet Regional Archives, Indiana University.*

had throttled his car down as far as it would go, and because of the noise it made, he wasn't sure. The door of the Hudson flew open, and Simbolmos saw a man wearing a chinchilla fur coat emerge and hurry into the drugstore.

Curious about the scene unfolding in front of him, Simbolmos continued watching, noting the broken right front window and the scrapes on the right-hand side of the Super Six Hudson, a seven-seater sedan that sold for around $2,000 at a time when a new Model T cost $298.

"I stopped when I seen him stop at the drugstore," said Simbolmos, who owned a garage with his brothers just down the street. "That's what made me think something happened."

Inside, the man in the chinchilla coat stayed just long enough to shout at owner Hershel Cannon to call both a doctor and the police before running out the door. Cannon, recognizing him as Harry Diamond, didn't ask questions but instead hurried toward the phone booth. His pharmacy clerk, James Storer, handed him two nickels so he could make the calls.

On the sidewalk, Thomas Kochis, walking home from his night shift as a railroad clerk at the ICC Railroad freight house located a few blocks west of the intersection of Melville and Chicago Avenues, heard what sounded like a shot right before a man in a fur coat jumped out of the car, running quickly in and out of the drugstore. As Kochis watched, Harry Diamond pulled a woman's limp body from the passenger side of the sedan. As Diamond headed toward the drugstore's entrance, Storer was there holding the door open.

"The first thing I knew he threw this form on the floor and starts for the back of the store," Storer said. "I intercepted him or rather followed him. It seems to me as if he wanted to wash his hands."

Diamond had blood on his hands, and his face looked like he had wiped the blood on his face as well. But Diamond didn't go into the washroom.

"Then is when he made the remark that he had shot the Negro and had hoped he killed him and he placed his hands on me," said Storer, describing how Harry had put both hands on his shoulders and leaned toward him.

Trying to quiet Harry and possibly somewhat afraid, Storer pulled away, heading for the front of the store. Diamond wasn't too far behind, and Storer watched as he began to kneel by his wife, hearing him say, "'Honey, I didn't mean to do it.' And she in return said, 'You lie' or 'You're a liar,' I won't say which, and she says, 'You shot me for my money.'"

Cannon, having made his calls, walked over to the prone figure, recognizing her immediately as he had her husband a few minutes earlier. Moaning and gasping, with bloodied bullet holes in her fur coat, her face battered and

bleeding, Nettie D. Diamond was still coherent, her voice strong and her demeanor—astoundingly, given the circumstances—determined.

"Cannon, if I should die, make it public to know that this man Diamond killed me," she said to the pharmacist as he knelt down beside her and attempted to place his coat under her head. "You know that he killed me."

Harry, who still had blood on his face, had moved a little farther back from his wife.

"Honey, tell them that the Negro killed you, or shot you rather, instead of me," he said, seeming not to care who else besides his wife could hear him. By then Kochis and Simbolmos had also entered the store. Whatever was going on, they wanted to be part of it.

"When I seen trouble and a person go in there I expect to see something," was the way Simbolmos later explained why he walked into the drugstore.

Frank Simbolmos, who, with his brothers, owned the Central Garage just down the street from the Calumet Drug Store, was one of those who testified against Harry Diamond. *Photo courtesy of the East Chicago Public Library.*

Nettie Diamond and Hershel Cannon had long been acquainted. She, too, was a pharmacist, a 1904 graduate of Columbia University's pharmacy school. Cannon had worked for her while she was married to Dr. Samuel Herskovitz, and even after his death, Nettie continued to run the pharmacy and lived, along with the couple's four children, above the business in a spacious ten-room apartment on the second floor. After marrying Diamond three years earlier, she had sold the business to Cannon for $16,000, and

Diamond moved in with Nettie and her kids. Cannon, now the owner of Calumet Drug Store, also paid her $300 a month in rent for the use of the first floor of the building. About a year ago, the Diamonds had moved to a newly built large brick home on Buchanan Street in Gary, a steel mill city just a few miles east.

While Dr. Herskovitz had been revered and his sudden death in 1916 at the age of thirty-one shocking, Diamond's current husband was anything but. Known to the police as a suspected thief and bootlegger, as well as owner of a roadhouse where girls could be had for hire and suspected of being involved in the slaying of an East Chicago policeman a few years earlier, he was, at age twenty-four, about eighteen years younger than his wife. A law school dropout, Harry Diamond was handsome, with dark hair, and looked in a way like Rudolph Valentino, a popular silent screen actor nicknamed "The Sheik" from a movie of the same name in which he had starred. Nettie, too, was considered good looking, fun and, as an

Accompanied by Dr. Frank Townsley, Nettie was taken by ambulance to Mercy Hospital in Gary, Indiana. *Photo courtesy of the Calumet Regional Archives, Indiana University.*

added bonus, was also a rich widow and shrewd businesswoman. It was her money that paid for the large diamond ring on Harry Diamond's finger, the chinchilla coat, the big house in a swell neighborhood and the chauffeur-driven Hudson.

As they waited for the doctor, none of the men surrounding Nettie believed she was in mortal danger despite the severity of her injuries.

"She seemed to be perfectly normal and was talking there in the drugstore saying that her husband had shot her and not the Negro," Cannon said later.

Edward Knight, former sergeant of police and now bailiff of the city court, who had arrived with Hiram Kerr, another East Chicago policemen, also had difficulty believing that Diamond, though badly hurt, was in any great danger.

"There was snow on the ground, and they had tracked it in the store and she was laying right in that," he would testify to a grand jury a short while

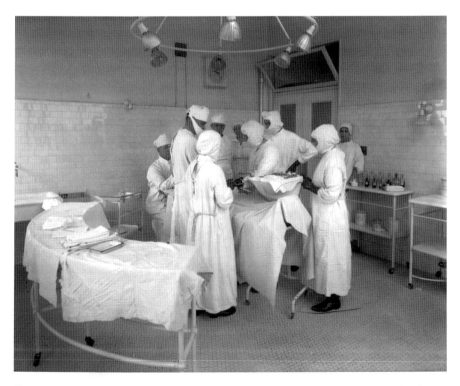

Townsley was one of several doctors operating on Nettie the afternoon she was shot in what would be a futile attempt to save her life. *Photo courtesy of the Calumet Regional Archives, Indiana University.*

later. Wanting to protect her from the cold slush water, he walked to the back of the store, where he ran into Harry Diamond. Diamond told him he'd had an epileptic fit and didn't remember what had happened to his wife. But Knight was more concerned about making Diamond's wife as comfortable as possible than listening to excuses. Indeed, he seemed more concerned than Harry, who didn't ask about his wife's condition.

Unable to find a blanket, he returned and offered to lift Nettie into a chair so she'd be out of the cold puddle of water.

"I did not realize she was really seriously injured because she was so rational and seemed so strong," he said. But Nettie told him she was too weak to sit up.

In the courtroom, when asked by William McAleer, the state's special prosecutor, whether Nettie's head was "all chopped up," policeman Kerr responded that it was broken like an eggshell. He also noted the discrepancy between her injuries and her ability to carry on a rational conversation.

"She talked with such strength," he said. "I couldn't realize how she was hurt so seriously."

Nettie was indeed extremely fragile. An hour later, at Mercy Hospital in Gary, doctors would discover she'd been shot four times, including once in the head, and also savagely beaten with the butt of a gun. The latter wounds were so deep that once her lustrous folds of dark hair were shaved, her skull could be seen. But the head wounds, as horrendous as they looked, weren't the problem. It was the gut shots in the abdomen, as well as severe blood loss, that were their biggest concerns.

At the drugstore she had once owned in a building where she had lived, Nettie, seeing Dr. Frank Townsley arrive, fixed him with a strong gaze.

"Dr. Townsley, do all you can for me," she said. "Get the best doctor. I believe I am going to die. I am badly injured."

Though he didn't say it right then, Townsley, who had fought in World War I and received a medal for his services, had certainly seen many grievous wounds and agreed with Diamond's assessment. He would later state that she wouldn't live. Now in the drugstore, he told Storer to call 271 for the ambulance. As Townsley comforted Nettie, Harry came up to her, saying, "No, honey, I didn't shoot you. The Negro shot you."

"No, he did not," she responded. "You shot me yourself."

"No honey, you are out of your mind. You don't know what you are talking about," said Diamond, looking down at his wife. "Don't tell them I shot you. Tell them the Negro did."

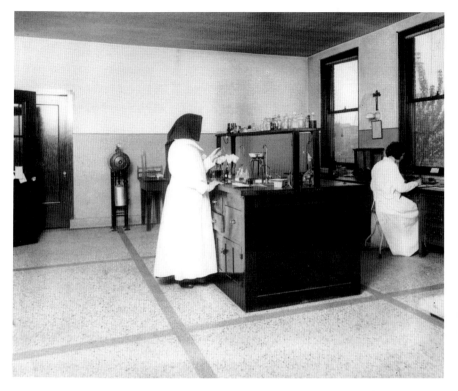

St. Catherine's Hospital, which was to open five years later in Indiana Harbor, was just a few short miles from the Calumet Drug Store. Mercy was considered one of the best. Shown in this photo is the laboratory. *Photo courtesy of the Calumet Regional Archives, Indiana University.*

Nettie insisted Harry was the shooter, not William Armstrong, their seventeen-year-old African American chauffeur who had been driving them earlier that morning

"You shot me yourself. The Negro didn't shoot me," she told him again, and then to the group of onlookers, she continued, "He has $20,000 of my money, and that is the reason he shot me."

Handsome, suave and always a con, Harry dropped to his knees next to his wife and tried to kiss her, all the time saying their chauffeur had fired the shots.

"No, no Harry!" Nettie cried out. "You are my husband but you shot me. Don't touch me. Go away. Go away."

As Kochis and others listened, Nettie continued to talk.

"She said about a will," Kochis said. "She said she willed him $20,000 a few days before and she did not think he would kill her for that $20,000 so quick."

Cannon, by then, had found a cot and set it up behind the prescription counter. Townsley and Knight, gently carrying Nettie, laid her down. Harry was behind the prescription case, too, and Knight and Kerr nearby, where they heard an exchange between the couple.

"Harry, why did you shoot me? Why did you beat me over the head with a gun?" Nettie asked him.

"I got a fit," he replied.

That was enough for the two men; Kerr grabbed Harry, sitting him on a chair about fifteen feet away from the prescription counter, telling him he was under arrest for attempted murder. Harry faked a seizure, sliding off the chair and onto the floor. Kerr's reaction was swift and none too gentle.

"I got him by the nape of the neck," he said, "and jerked him back and sat him on the chair." Kerr also added that Harry hadn't fallen in any way where he could have hurt himself.

Harry didn't try that trick again, remaining upright for the next ten minutes until Kerr and Knight led him out of the store.

Nettie's turn to leave came shortly after.

"The ambulance came," said Storer, "and as she was carried to the door I could hardly recognize her as a human being. Her face and head appeared to be a mass of matter; it didn't look like a face of an individual at all. There were abrasions on the head and blood clots beneath the right eye. You could not recognize that as a gunshot wound, only it was very serious to me. Dr. Townsley said to me they were bad wounds."

And so, as Nettie Diamond traveled east toward the hospital accompanied in the ambulance by Townsley, her husband was heading in a different direction—to the "calaboose," or jail, on the first floor of the East Chicago City Hall.

In the ambulance, Nettie questioned the doctor about her chances.

"She wanted to know if I thought she would get well," said Townsley, who was a family friend as well as the deputy county coroner of Lake County. "Well, I hesitated about answering her. I felt there was no possibility, but I did not like to tell her at that time."

When the ambulance arrived at Mercy Hospital, William Armstrong was already there, being treated by the doctors. He, too, had been shot and beaten, but unlike Nettie Diamond, he was expected to live.

At East Chicago City Hall, East Chicago chief of police Crist Struss, showing Harry Diamond a bloody and battered .32 Smith and Wesson, which Kerr had found on the Hudson's front seat, asked whether the gun was his. It was, Diamond said, but Armstrong had taken it and tried to shoot him. It was

Spotlessly clean, the patient wards were managed by the nuns, who had trained as nurses. Three years after Nettie's death, St. Catherine's Hospital in Indiana Harbor, just a few miles from the Calumet Drug Store, would open. If she could have made it there, would she have survived? *Photo courtesy of the Calumet Regional Archives, Indiana University.*

he, Harry Diamond, who had taken it away from the younger man and, at his wife's insistence, aimed at the chauffeur in an attempt to kill him.

But though the police found the gun easily enough, missing from the automobile were diamonds and a check for $17,000. They would also find out later that Nettie's safe, where she kept a large sum of cash, would also turn up missing, as would the fur coat she had worn on her way to the hospital and that hung in her room as doctors performed surgery in a hopeless attempt to save her life. Also gone was the will she had drawn up just days before leaving Harry only $20,000 instead of her entire fortune.

Later it would be learned that Diamond had also taken out a $25,000 life insurance policy on his wife just one month before she was killed. Not only that, but he also tried to adopt Nettie's children; however, her lawyer discouraged her from allowing him to do so.

The *Lake County Times* reported that Diamond had arrived at the office of U.S. commissioner Charles Surprise in Hammond about three weeks

A head nurse on the grounds of Mercy Hospital. Built in 1908 and now abandoned, Mercy had the distinction of being where singer Michael Jackson and his siblings were born. A first-class building when opened, the facility was rated class A by the American Hospital Association. *Photo courtesy of the Calumet Regional Archives, Indiana University.*

before the murder with passport photos of himself, Nettie and their infant daughter, Gertrude Fay. Surprise noted that most passport applicants fill out the form first and then have photos taken. Nevertheless, he gave Diamond the application forms. Harry said he'd be back the next day but never showed up again. Speculation was that he intended to get rid of Nettie while they were overseas.

Early reports also indicated that Diamond had taken out a $5,000 life insurance policy on their chauffeur.

These were just a few mysteries about the case that would fascinate not only the Northwest Indiana and Chicago newspapers but also those from around the state and the country as far away as Oklahoma for the next eighteen months.

ACKNOWLEDGEMENTS

Trying to retrace the history of the people involved in the 1923 slaying of Nettie D. Herskovitz Diamond was like reaching for wisps of smoke.

It was the archivists at various libraries, county and state courthouses, historical societies and others willing to share memories and photos who helped me hunt down Nettie's story. Without them, it would remain untold and unknown.

I'd like to give special thanks to all those who dug through dusty files and squinted at blurry microfiche, pulled down heavy boxes of photos so I could sort through them and helped me in so many ways. That includes Ron Cohen, professor emeritus of history at Indiana University Northwest and author of many books himself, who gave me the advice to "just write the book" when I talked to him about all the rabbit holes I encountered while doing research and my brother, Tim Simon, professor emeritus at Notre Dame, who shared with me his invaluable compilation of East Chicago historic collections. Also a special thanks to Mary Ben Young, who, at ninety-five, remembered so much about Indiana Harbor history and its Romanian culture (and coincidentally, lived with her parents for several years as an infant above my grandparents' dairy; the photo is included in this book). Of course, there's Arch McKinley, a great chronicler of East Chicago history, who was invaluable, as well as Marlene Posner of the Northwest Indiana Genealogy Society who patiently helped me navigate the court records. Along the way, I made many friends, such as the wonderful researcher Tara Parks at the Lake County Court Probate division; Pamela Buchstaber, whose

ACKNOWLEDGEMENTS

great-grandmother Bertha Buchstaber was Nettie's good friend; and Andy Prieboy, another Indiana Harbor fanatic such as myself, and reconnected with my favorite teacher, Babs Cohen Maza, whose grandmother Anna Cohen Fishman played a great part in Nettie's tale.

Thanks to those who worked so hard, I was able to learn Nettie's story and share it with you.

Larry Clark, Genealogy Department, Valparaiso Public Library

David Hess, Indiana Room Librarian, Gary Public Library

Gregory J. Higby, PhD, RPh, Executive Director, American Institute of the History of Pharmacy, University of Wisconsin–Madison

Alan January, Director of Patron Services, Indiana State Archives

Lake County Public Library

James Lane, Professor of History, Indiana University

Jennifer McGillan, Archivist, Columbia University's Heath Sciences Library

Stephen McShane, Co-director and Archivist/Curator, Calumet Regional Archives, Anderson Library, Indiana University Northwest

Yvonne Monroe, East Chicago Room, East Chicago Public Library

Kevin Murley, Indiana Supreme Court Administrator

Northwest Indiana Genealogy Society

Stephen E. Novak, Head, Archives and Special Collections, A.C. Long Health Sciences Library, Columbia University Medical Center, New York, New York

Debra Powers, Reference Librarian, East Chicago Public Library

Martha Riley, Librarian, Archives and Rare Books, Bernard Becker Medical Library, St. Louis, Missouri

Kirwin Roach, Adult Service Provider at St. Louis Public Library

Steve Shook, who grew up in Porter County and shared his photo and post card collection so generously

Philip Skroska, Visual Archivist, Archives and Rare Books, Bernard Becker Medical Library, St. Louis, Missouri

Carolyn Smith, Processing Archivist, Rare Books and Manuscripts, Columbia University

Phillip Thayer, Clerk, East Chicago

Alicia Vickers, Clerk of the Indiana Supreme/Appellate Courts

INTO THE NEXT CENTURY

I grew up in Indiana Harbor more than a half century after Nettie died and—as I would find out later—as a young child lived just a block from her best friend's house. It would be another forty years before I learned from my mother, at the time about ninety-four but still in good health and mind, that before she married my father, she'd dated a man I knew as Bernie Hurst.

My mother was from East Chicago, Hurst from Indiana Harbor. She didn't say how they met, but they would take the train to Indiana University together until the Depression. When money became tight, my grandfather decided he could only afford to send his two sons—and besides, girls would marry and didn't need to be educated for that. And so, my mother moved home and took a job. Bernie would continue, graduating and returning to Indiana Harbor, where he ultimately became my elementary school principal.

He gave my mother a ring, which she said she still had all those years later, though I never saw it. Ultimately, he decided he had to marry within his faith. My mother's story was startling enough, but then she added, in a rather offhand way, that Bernie's parents had been murdered near where the Palm Grove restaurant once stood. Hurst wasn't his real name, she continued. After the murder, they changed their last name.

That was so long ago, more than seventy years of my mom's life had gone by since, and she couldn't remember exactly what their last name had been—Hurshwitz, Hershcowitz, something like that.

Mr. Hurst, an avid tennis player (my mother's sport, too), the child of murdered parents? He had, I had always thought, shown much favoritism

toward me, selecting me to be the nurse's aide when the school nurse wasn't available—I was a ten-year-old allowed to take temperatures, clean wounds and even send a child home because she or he seemed ill. I, of course, wanted to know more.

It was not an easy journey to discovery. I first used Google archives, searching for old newspapers, looking for stories about the murder. Because I didn't have the year, I had to search through the '20s, and because I didn't have the exact spelling, I had to search through many names. But I finally found a single line about the murder of a Nettie D. Herskovitz in Indiana Harbor in February 1923. Using the name and date, I called the Lake County Public Library in Merrillville, Indiana, and within three days, one of its research librarians had found over one hundred pages of old newspapers with stories about the murder.

It was a beginning of both learning about the case and also seeing how oral history challenges and changes what is written down. Mr. Hurst's mother had indeed been murdered, but Mr. Hurst's father wasn't murdered; he had died seven years earlier at the young age of thirty-one in a hospital in Chicago. His stepfather had died, not that year but the next, becoming the first person in Porter County to be condemned to death in almost ninety years and the only Jew ever to be executed in the state.

During my research, I would run across other twists on what really happened.

"She was shot by Lloyd and Bernie's father because she was having an affair with the black chauffeur," said Ardash Daronatsy, my sister-in-law's uncle, who had worked for Bernie's brother Lloyd for decades.

"His father shot his mother," Babs Cohen Fishman told me.

But it was my suppositions about Nettie that were most off mark. I had supposed from the newspaper articles that it was a classic account of a lonely older widow marrying a young cad who only wanted her for her money. But it turned out that wasn't the whole story either. I don't know if Nettie was lonely, but she certainly wasn't gullible. She had Harry Diamond sign what was then called an ante-nuptial right before they married on January 31, 1920. She was educated beyond most women of her time—earning a pharmacy degree at the College of Pharmacy of the City of New York, which would become part of Columbia University the same year she graduated. The requirements for that year's graduates included courses in commercial pharmacognosy, materia medica, chemical analysis, experimental inorganic and organic pharmaceutical chemistry and toxicology. In the long list of graduating seniors in the class of 1904, only 9 were women—Sarah

Rosenblatt, Bertha Lopez De Victoria, Noe Rene Hirsch, Carollyne Glass, Allison Androvette, Wilma Backman, Rose Wilkes, Leonie Marculescu and Nettie. Interestingly, 2 of the women, Marculescu and Wilkes, had preceptors with the same last name, indicating a family relationship. Indeed, in 1900, the state of New York led the United States in female pharmacists, with 140 registered to practice in that profession out of a total of 1,900.

According to Jennifer McGillan, archivist at Columbia University's Health Sciences Library, in order to receive her diploma, Nettie had to be twenty-one, be of good moral character and have had

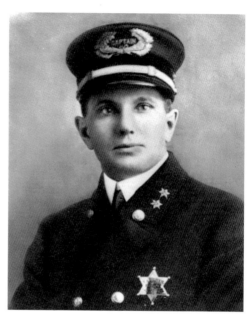

Crist Struss, chief of the East Chicago police, met with Harry Diamond shortly after his arrest. *Photo courtesy of the East Chicago Public Library.*

four years of practical experience with a person or persons qualified to the business of dispensing pharmacy (aka her preceptor), though she would have received credit for time spent in the labs at the school as well. She also had to attend two full courses of lectures.

Greg Higby, PhD, RPh, executive director of the American Institute of the History of Pharmacy at the University of Wisconsin–Madison, referred to *A History of the College of Pharmacy of the City of New York*, written in 1929 by Curt P. Wimmer, a professor of pharmacy, where it stated:

> *A diploma will not be delivered to anyone who has not attained the age of twenty-one years and has not had at least four years' practical experience where drugs, medicines and poisons were dispensed and retailed and prescriptions compounded. The time spent in the laboratories of this College will count as a part of this practical experience. To those who have not had the requisite experience, nor attained the age of twenty-one years, a certificate of examination will be issued, to be subsequently exchanged for the diploma when all the necessary conditions have been fulfilled.*

This means that though Nettie did graduate in 1904, she may not have been awarded a diploma until later.

Of the grandchildren I spoke to, none was sure of Nettie's maiden name, though they thought it was probably Sachs. That was the name said to be her maiden name in news reports and in the list of graduates from the College of Pharmacy of New York in 1904, and on Lloyd's wedding certificate, he gives Sachs as his mother's maiden name and her parents' country of origin as Romania. Her family knew nothing about her parents or even where she came from. Several thought she came from New York, possibly emigrating from Eastern Europe—probably Russia or Lithuania. Another said that she had immigrated to Houston to care for the child of a doctor whose wife had died in childbirth and then moved to New York. In the 1910 census, taken on April 22, when she and Sam were living with Pearl, who was just seven months old, in Indiana Harbor, she listed both of her parents as emigrating from Romania. She also said that her marriage to Sam was her first, she had no other children (could Sam not know of Edward and Noah?) and her age was twenty-two.

No one I talked to seemed to know the date of birth, and even her contemporaries gave different ages. Harry testified that she was twenty-nine; her tombstone says thirty-nine; her death certificate says she was thirty-three, having been born on May 1, 1889; and most newspaper accounts say she was forty-two. Searching ship manifests and other documents using May 1 (figuring a woman may fib about her birth year but not her birth month and day), I found no Nettie D. Sachs whose background matches the clues she left behind. And besides, if, as her very, very last will says, Edward Sachs was a son from a previous marriage, then Sachs might not have been her maiden name but the last name of another husband.

To make it even more confusing, one of her husbands, Louis Joshua Zauderer, told reporters in 1908 that Nettie was fifteen when she married him in 1902. That means she might be the Nettie Sachs, age four, listed in the 1892 New York census. Other family members were parents, August and Amelia, and siblings Elsie, age six; August, three; and one-year-old Florence. But again, a problem arises—a newspaper article says her mother's name was Mary, and her death certificate lists Mary Sachs as her mother as well. Or she could have been the Nettie Sachs who lived in St. Louis, Missouri, and was sixteen in 1900. That might fit, as she and Zauderer—he was born and raised in New York—moved there after she graduated, and an article about their divorce says that her son Edward lived with Nettie and her mother, Mary Sachs, in St. Louis.

And who were her other husbands besides Zauderer, Herskovitz, Diamond and possibly a Mr. Sachs? In 1902, a Nettie Sachs was divorced by her husband Henry Sachs in Evansville. They had been married for a year but lived together for less than a month as she would not, he claimed, fix him even one meal. In the summer of 1918, at age twenty-nine (or so she said), she married Dr. Sol Golden in Chicago. Three years later, she married Harry Diamond in Waukegan, Illinois, using the last name Herskovitz and saying she was a resident of Chicago and twenty-three years old (Harry was twenty-two and must not have been good with math or he would have figured that meant she had graduated from pharmacy school at age seven). I would find some answers but not as many as I would have liked. She remained elusive—more so than other people in her life. Finding the history of Sam, Harry, Anna and many others was easy, but Nettie seemed to have appeared around the turn of the twentieth century with no traces of her life before.

As I poked and probed through file cabinets full of dusty papers and old land records with handwritten entries, I soon found that Mr. Hurst and my mother's romance wasn't my only connection to Nettie. No contemporaries

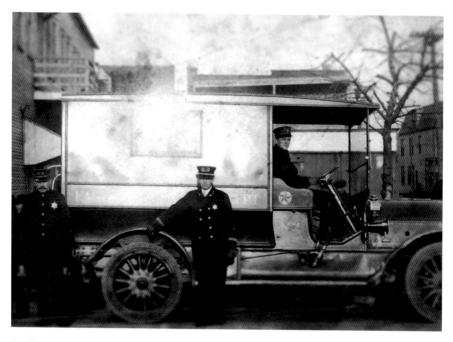

An East Chicago paddy wagon like this would have been used to haul Harry Diamond to jail. *Photo courtesy of the East Chicago Public Library.*

of Nettie were still alive, but I called people who would have been just one generation removed, hoping that they might have heard a tidbit of her story.

I found the phone number for Babs Cohen Maza, who had been my fourth-grade teacher at Washington Elementary, and in our conversation learned she was the granddaughter of Anna Cohen Fishman. Pearl Herskovitz, Sam and Nettie's eldest child, had lived with Anna after her mother's death, and Lloyd and Bernie had stayed there as well, though Bernie, at least, had lived with other relatives too. And in another odd twist, Anna's home was just around the corner from my Grandma Simon's four flat where my family and I had lived until I was eight years old. Both buildings still stand.

Babs remembers Pearl as beautiful, smart and delightful. She was aware that the Hurst children were orphans and that there had been a murder, but she didn't know more than that—the story she had heard was that Nettie's husband had caught her cheating and shot her. Years later, when Babs taught at Washington Elementary when Bernie was the principal, she said he never mentioned those younger years at Anna's house. She recalls him being strict and exacting, while I recalled him as almost uncle-like. Lloyd, Babs told me, was always friendly and would refer to their younger days together. But Bernie was a closed book. He also seems to have been somewhat restless in his teens. His daughter mentioned that he'd moved about between homes, and there was another mention that he had briefly run away. The concept of Mr. Hurst as a rebel was a distinct contrast to the presentation he made to the staff and students at Washington Elementary—dressed in his tweed jackets, always poised and, in my memory, looking like the perfect English gentleman. But of course, he wasn't; he was a Romanian American born in Indiana Harbor.

Shifts in time were disguising some of the facts. The Herskovitz children didn't change their name to Hurst until much later. Yearbooks from Indiana University show that Bernard and Cecil were still known by the last name Herskovitz during their time in college. Mr. Hurst's parents weren't both killed by gangsters as my mother thought; Sam was already dead. It was just Nettie traveling on that industrial road near the Cudahy Dutch Cleansing Plant on the old Cline Avenue.

There were other threads tying the past to the present. My father, Dan Simon, went to school with the Herskovitz children; he served on the student council with Lloyd. He would have graduated with Pearl, only his parents sent him away, along with my uncle Charles, to a private high school where many Romanian boys went back then. My dad grew up on Pennsylvania Avenue, and the Herskovitz family had property one street

over on Block Avenue and owned pharmacies close by on Michigan Avenue. Sam Herskovitz was Romanian, and it's not a stretch to think that my grandparents, who spoke Romanian much easier than English, would have taken their children to a Romanian doctor who practiced nearby and bought medicines and other sundries at a store owned by a fellow countryman as well.

Maybe Nettie and Sam bought milk from my grandparents' dairy. Indeed, it could have been my father, leading the horse-drawn milk wagon through the streets of Indiana Harbor, who delivered it to them. But these are things I will never know. And I must be content with finding out as much as I can from old records in courthouses, newspaper accounts, archives and fading memories.

Of course, my dad would have heard the story—most likely spoken about among the Romanian immigrants who congregated at the Transylvanian Hall, the social and cultural center on Pennsylvania and Washington Avenues. Articles about it might have appeared in the Romanian newspaper my grandmother read every day. But my dad had died at age eighty-eight, and by the time my mother told me the story, he had been gone for eight years.

The Indiana Harbor of Nettie's time was different from the Indiana Harbor that I grew up in. But both are now gone, the vibrancy of its boomtown ambience when Nettie moved there and the established prospering mill town of my day having given way to abandoned factories, businesses and homes. Some places remain, though, that both Nettie and

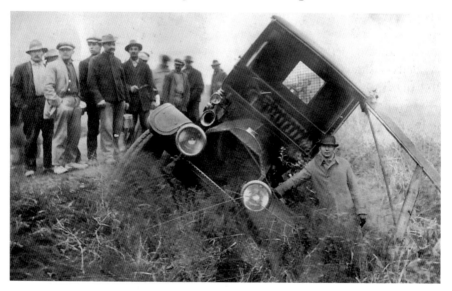

Police Chief Struss on the right stands next to one of East Chicago's patrol cars, which has gone off the road. *Photo courtesy of the East Chicago Public Library.*

I would remember. Anna Cohen Fishman's home at Grand Avenue still stands and looks solid and attractive. So does my grandmother's four flat and the East Chicago City Hall where Harry was incarcerated. But for the most part, the bright explosion of a city born of railroad and steel is now just a shell, though the mills still operate but no longer employ tens of thousands of people.

The city of East Chicago was incorporated in 1893, the same year as the great Columbian Exhibition on the South Side of Chicago. It was called the Twin City, with East Chicago (its western section) separated from the area known as Indiana Harbor by a vast rail yard that served as the rail gateway to Chicago and the Little Calumet River. It was in Indiana Harbor where steel mills stretched along the beachfront for shipping materials such as ore, iron and steel up through the Great Lakes and, depending on how far they were going, to the Mississippi River or the St. Lawrence Seaway. In between, near the river, is an area of Indiana Harbor called Calumet, where Sam and Nettie lived and owned a drugstore.

Lovely homes lined many of the streets and encircled, on three sides, Washington Park with its greenhouses, zoo, tennis courts, playground and swimming pool.

Now that my mother is gone, I've looked for the ring from Bernie Hurst she said she still had tucked away, but I can't find it though she left all her jewelry to me. It would be one more connection to Nettie and her life and death.

2
LAST WILL AND TESTAMENT

"It was about five-thirty when she waked up and the nurse asked her if she knew who was at her bedside and she said, 'Yes, it is the dearest friend in the world, Anna.'"

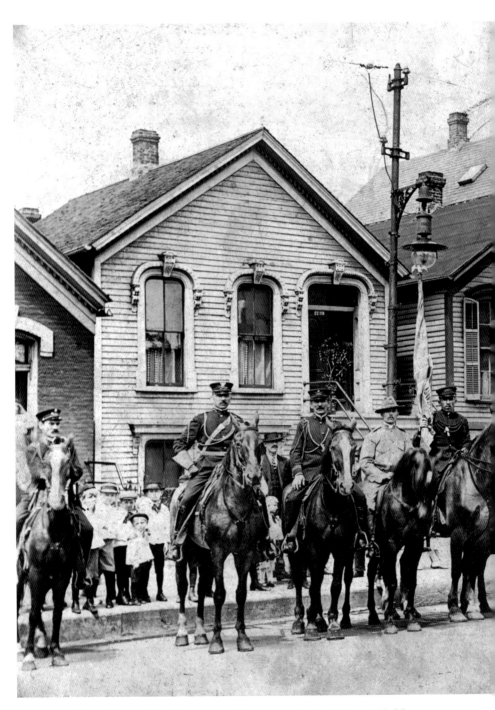

The mounted East Chicago Police Department. *Photo courtesy of the East Chicago Public Library.*

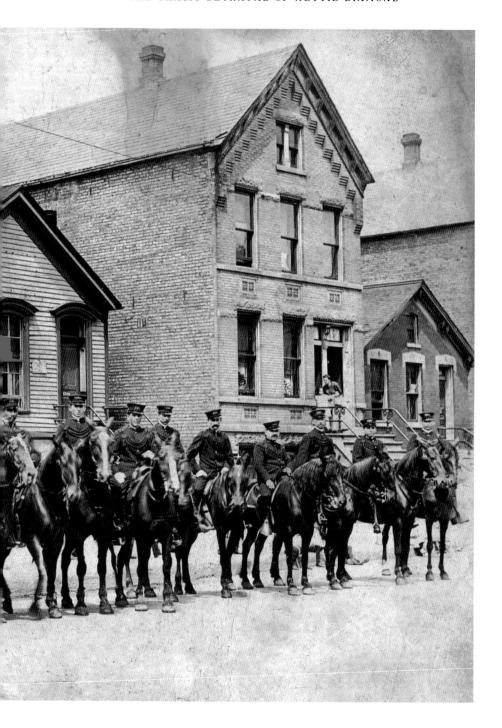

Bleeding from a hemorrhage caused by the ether given to her during the operation, Nettie also had a clot of blood caught in her throat, preventing her from talking until it was removed. But then, once again, Nettie made her statement to all in the room—one so crowded that Fishman couldn't remember all the names of the people there. The ones she did recall were Pearl; a nurse; Dr. Frank Townsley; Dr. Yarrington, one of the surgeons who had operated on her earlier that day; and Mrs. Bertha Buchstaber, a widow who had been staying at Anna's before moving to Cleveland, according to the paper. Just a few days earlier, Anna had hosted a goodbye party for her friend, and Nettie had attended. Also there was Harry's sister Lena, who listened to Nettie as she, in Anna's words, "kept talking and telling that Harry had shot her."

"She wanted me to take care of her children and take care of everything else," Fishman told the judge. "She was afraid she was going to die, and she wanted someone to take care of everything."

In the background, as Nettie talked, Dr. Townsley and a nurse were carrying on a separate conversation.

"The nurse told the doctor 'she did not respond,' and after the doctor left her bedside, she called me over and said to me, 'Did you hear that?'" recalled Fishman. "I said I did, and she said, 'Do you know what that means? That means death. That means I am going to die.'"

As Anna sat by her bedside, Nettie told how she'd left $20,000 to Harry in her new will. Anna advised Nettie to change her will immediately.

Nettie, who seemed to both know but not want to accept that she was dying, said, "So you do know I am going to die, do you?"

But Nettie was practical; she was a pharmacist and the widow of a doctor, and her knowledge of medicine and her own condition made her very aware that she needed to change her will and needed to do so immediately. She told Anna to call her attorney, and he, knowing the urgency, arrived at the hospital a short while after Anna's call. And so that evening, with Anna, Pearl and others present, Nettie dictated her very last will, the one that would leave Harry penniless:

Last Will and Testament of Nettie D. Diamond,
Formerly Nettie D. Herskovitz
I, Nettie D. Diamond of the city of Gary, Lake County, Indiana, being of sound mind and memory, but realizing the uncertainty of life, does [sic] hereby make, publish, sign and declare this to be my last Will and Testament, hereby revoking any and all other wills heretofore by me made.

Item I
It is my will and I hereby direct that all my just debts be first paid.

Item II
I hereby give, will and bequeath to my son, Edward Sach, who was born to me by a former marriage, the sum of Two Thousand Dollars ($2000.00).

Item III
I hereby give, will and bequeath to my daughter Fay Diamond the sum of Three Thousand Dollars ($3000.00).

Item IV
I hereby give, will and bequeath to the rest of my children by a former marriage, namely: Pearl Herskovitz, Lloyd Herskovitz, Bernard Herskovitz and Cecil Herskovitz, all the remainder of my property, real personal and mixed of every kind and character with wherever found to be this absolutely share and share alike.

Item V
I hereby designate and appoint J.G. Allen, Vice President of the Indiana Harbor National Bank[,] to be the executor of my will and request that he carry out the promises named herein.

The witness where of I have herewith signed my name this the 15th day of February 1923.

Nettie D. X [her mark] *Diamond*

The above and foregoing will, written and in long hand, consisting of two pages of which this is one, was signed by Nettie D. (Herskovitz) Diamond as and for her last will and testament in our presence and we in her presence and at her request and in the presence of each other signed said will as witnesses, this the 15th day of February 1923.

James A. Murray
Anna V. Cohen Fishman

ORPHANS CARED FOR BY WILL:
MOST OF THE ESTATE IS IN REAL ESTATE
—Lake County Times, February

While drawing up her will, her attorney asked Nettie whether she wanted to leave Diamond any of her estate.

Stating no, Nettie informed him that during the three years she was married to Diamond she had given him various sums totaling about $20,000.

The estate was worth much more than that, despite the missing stocks and jewelry. To get an idea of Nettie's real estate holdings, I tacked two old Indiana Harbor street maps on my wall. Going through the pages and pages of warranty deeds and mortgages I'd found in the assessor's department at the Lake County Superior Courthouse, I started posting little red markers for the properties she owned. Soon the map was littered with squares of red. I used blue to show the real estate holdings of Sam Herskovitz's brother, Marcus Herscowitz (he spelled his last name differently than Sam), an attorney, and his wife, Sophia (they didn't own property together all the time), and the blue squares also began to cover the street maps. Sam's brother David and his sister Etty had fewer squares; they, too, seemed to be flipping properties—but no one more so than Nettie. She bought lots and then sold them and bought more. At the time, property values in Indiana Harbor were rising, and Nettie seemed to be flipping properties at a rapid rate. In one year alone, I found dozens, and that's with just an hour or so spent looking through the large handwritten ledgers at the Lake County Assessor's Office.

But there was even more. William Murray, whose brother was the attorney who witnessed Nettie's final will, was appointed executor of her estate. In his billings to the estate, he lists the dates and amount of time, as well as descriptions of his work.

On February 21, 1923, he spent the day probating her will, checking accounts at the East Chicago State Bank and making inventory of a lock box at the Indiana Harbor National Bank. On February 24, he visited "all the banks in Gary." The next day, he was back in Gary checking accounts, mortgages and interest at the banks. Two days later, Murray checked accounts in a broker's office in Chicago. Between March 4 and 6, he made a trip to St. Louis to open a "safety deposit box." March 7 again found him in Chicago investigating records of a broker's office and visiting banks, "looking for lock box and causing same to be padlocked."

Though the amounts found in all these brokers' offices and bank vaults aren't included in the estate papers, it appears that Nettie had squirreled away money in many places.

Even when Sam was alive and one might think Nettie would be burdened with an ever-increasing number of children with her husband, she played a part in the building of their business empire. She and Sam, along with Louis Steimer, formed the Calumet Drug Company on June 30, 1913, with capital stock amounting to $7,500. Sam was president, Steimer vice-president and Nettie secretary and treasurer. Less than three years later, Sam would be dead, and Nettie would die before ten years had passed.

As for Steimer, whether he was alive in 1946, repeated notices from the attorney general for the state of Indiana sent to Nettie at what had been the Calumet Drug Store went unreturned, and the Calumet Drug Company was disbanded on March 25, 1946.

According to the Articles of Association in the Indiana State Archives, the object of the association was to "own and operate drugstores and pharmacies and to compound and sell prescriptions, medicines and drugs of all natures and descriptions, together with other sundry articles incidental to such business and to conduct mercantile operations necessary in carrying on said business, and shall also have power to own and convey such real estate necessary and incident to such business."

The association was to have an existence of fifty years, according to the documents, and even had a corporate seal, which was a disk encircled by the words "Calumet Drug Company" of East Chicago with the word "seal" in the center of the same.

The will Nettie signed a few days before her death, the one cutting Harry's inheritance down to $20,000, was nowhere to be found, though the original will, granting Harry the entire estate, still existed. But it didn't matter. By drawing up a new will, Nettie had effectively cut Harry off from her fortune. Even if he were to be found not guilty, as unlikely as that seemed, he would be left with nothing. And so his grand plan to be rid of the wife but keep her money disappeared. Harry had, literally, killed her for nothing.

PURLOINED! MISSING MONEY, JEWELS AND CLOTHES

LIGHTS IN HOME ALL NIGHT
—Lake County Times

Lights burned all of Thursday night in the Harry Diamond home. Neighbors saw them. The Herskovitz family believes many valuable papers and costly clothing of the dead woman were stolen that night.

"As soon as my aunt was dead," said Louis Cohen, Nettie's nephew, who was on his way to visit his aunt when he heard about the shooting, "the Diamonds came to the hospital for her fur coat—a coat that was covered in blood and punctured with bullet holes. What would they want of it but to sell it?"

VALUABLE PAPERS, SAFE AND CLOTHING BELONGING TO MRS. DIAMOND STOLEN, HER RELATIVES CHARGE

$10,000 THEFT OF CLOTHING IS CHARGED: DEAD WOMAN'S APPAREL RECOVERED IN CHICAGO
—Lake County Times, Monday, February 21, 1923

Recovery of nearly $10,000 worth of clothing and the arrest of Ruth Diamond, the twenty-two-year-old bookkeeper employed at Frank Simard's plumbing company, at one-thirty on the afternoon of February 21 are the latest sensational developments in the Diamond murder case, the *Times* reported.

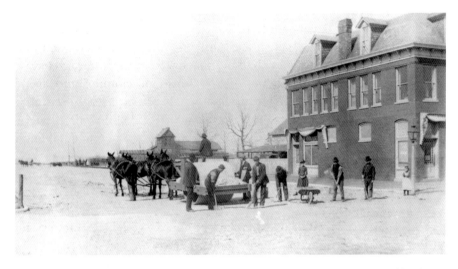

One of the first buildings to be constructed in East Chicago. Before, this stretch of land was one of the most inhospitable—marsh, wetlands, sloughs, swales and sands. The Fort Wayne train depot can be seen in the background and later became the site of the mayor's office. *Photo courtesy of the East Chicago Public Library.*

The article continued:

> *Ruth Diamond is a sister of Harry Diamond. The clothing was recovered by Captain William Linn, who has been working feverishly on the case since the Diamond home at 447 Buchanan was looted while Mrs. Diamond lay dying in Mercy Hospital. Linn said the clothes found belonged to Nettie Diamond and were recovered at an address at Monroe and Des Plaines streets in Chicago.*
>
> *The warrant for Ruth Diamond's arrest was sworn by Marcus Herscowitz, the brother-in-law of Mrs. Harry Diamond and an East Chicago attorney. Ruth Diamond refused to talk and was booked and turned over to Mrs. Nora O'Hare, the police matron who locked her up.*

At her preliminary hearing, William Matthews, attorney for both father and daughter, as well as on the defense team for Harry, argued that, as Herscowitz was neither executor nor creditor of Nettie's estate, he had no right to be the complaining witness. Matthews followed up his complaint about Marcus Herscowitz with another argument: because Ruth was Harry's sister, she may have entered the home "with the presumed authority because of the relationship."

In case those arguments wouldn't work, Matthews added another—Nettie's clothes really belonged to Harry, so his family had every right to them.

THE TRAGIC BETRAYAL OF NETTIE DIAMOND

The judge didn't buy it, and Ruth was bound over to the criminal court.

Anna Fishman Cohen had earlier testified at the coroner's inquest that practically everything of value had been stolen from the home, including $2,000 worth of silken lingerie, $5,000 worth of clothing and all of her jewelry. Anna said that a great amount of Nettie's estate had also disappeared. She said Nettie was worth about $100,000 at the time of her death, but all that was left was about $75,000 in real estate holdings. Some $40,000 in securities had disappeared.

The clothing, including a fur-lined overcoat stolen from the Harry Diamond home, was shipped in a wooden box via American Express Company to Chicago.

Pearl Herskovitz identified all the clothing as belonging to her mother and the fur-lined overcoat as the one her father had worn.

It took the police two days to hunt down Joseph Diamond, the father of Harry and Ruth, who was also charged with grand larceny. Father and daughter were arrested on the same warrant but would have separate trials.

Within three days of her arrest, Ruth went on trial before special judge Hugh McLaughlin. Nettie's children by Sam Herskovitz were in court to testify, as was East Chicago police captain William Linn. According to him, after Ruth's arrest, she confessed to stealing the clothes the day of Nettie's death with the intent to first ship them to St. Louis, but then changing her mind, she sent them to Chicago.

Nettie's clothes were removed from a large wooden box for the Herskovitz children to identify. It was, according to one newspaper reporter, a very sad scene.

The search for Nettie's belongings had started soon after she died. Gary police, armed with search warrants and accompanied by Pearl Herskovitz, went to the home of Harry Diamond's family. The search was fruitless, and none of Nettie's belongings was found.

"It's funny where things went," Pearl remarked. "You people were the last ones to have the key."

"We only got the baby and the clothes for it," Esther Diamond, Harry's mother, responded as she walked the floor with the six-month-old baby in her arms. "We wouldn't take anything that didn't belong to us."

"No, I suppose not," was Pearl's retort. "What was done with the key?"

Neither Esther nor her daughter, who was there at the time of the search, could account for the missing key to Harry and Nettie's house. They said they believed Fanny Diamond had it.

"Where is she now?" asked one of the policemen.

Dan Simon, who used to make deliveries for his parents' Indiana Harbor Dairy in the late 1910s and early 1920s, remembers walking alongside the horse that knew which houses to stop at for deliveries. *Photo courtesy of the East Chicago Public Library.*

"Why do we have to tell you every place we go?" Harry's sister harshly responded. "She's in Chicago."

When the police asked what Fanny was doing in Chicago, her sister replied that she had gone up there for a rest. "We are all tired and sick over this," she said. "I think she was to go to a dance or something up there."

"Yes, probably took the stuff to Chicago," said Pearl.

It didn't get any better.

"Say, whose sweater you got on?" Harry's sister shouted. "That's mine. Take it off."

"Leave it on," the police sergeant told Pearl.

"Yes, leave it on," the other policeman said, and then, turning to Harry's sister, "You will have a chance to reprieve it if you want it."

"Oh, she can have it," said Pearl. "I don't want it."

That wasn't the only inharmonious occurrence between families. When first informed by Captain Linn of the Gary Police Department of

the murder, Harry's father lamented that his son had ever married the rich widow.

While his wife sank to her knees, rocking back and forth with her hands clasped across her breast, Joseph Diamond, who had almost collapsed at the news, began pacing the room while running his fingers through his hair.

"What shall I do? What shall I do?" he repeated. "I told him not to marry the woman. She was too old—forty or forty-two years or older and he only twenty-two years old then. I told him not to marry her—a woman with five children."

He was referring, the newspaper reported, to the four Herskovitz children, as well as a son from a previous marriage who was at the time twenty-one or twenty-two years old.

Bernard Hurst, holding baby Fay in his arms, was at the scene as well, though there's no report of what he said, if anything.

4

HER DYING BREATH

By early morning following the shooting, Nettie, knowing she was dying, had summoned the police to her bedside. With her was Anna Fishman Cohen, her daughter Pearl Herskovitz, Dr. Townsley and Teresa J. Schramm, a registered nurse. Also there were Captain William J. Linn and Detective Arthur Windmueller of the Gary police force, the latter writing down her dying declaration. She told them how Harry had intended to murder both her and William Armstrong. He would then establish his innocence by claiming that Armstrong had killed her and that Harry had shot him while trying to defend her.

> RICH WIFE, DYING, RALLIES TO PIN PLOT ON SPOUSE:
> SAYS BOY HUSBAND SHOT HER AND CHAUFFEUR
> —*Chicago Daily Tribune*, February 16, 1923
>
> A deathbed statement in which Mrs. Nettie Diamond accused her husband, Harry Diamond, 18 years her junior, of a plot to murder her and their chauffeur for her estate and his insurance, so arranging the crime that blame should fall upon the chauffeur, was revealed after Mrs. Diamond's death at the Mercy Hospital in Gary yesterday noon.

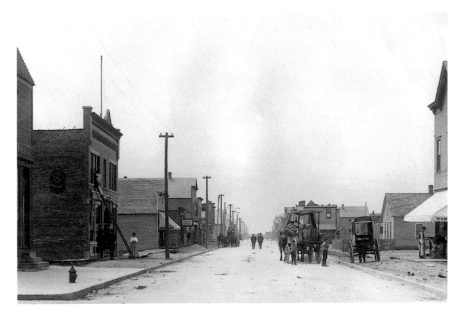

When Sam and Nettie moved to East Chicago, it was a boomtown, but like many boomtowns, it had difficulty keeping up with its growth. Even major city streets such as Michigan, Pennsylvania and Chicago Avenues wouldn't be paved until the 1920s. *Photo courtesy of the Calumet Regional Archives, Indiana University.*

The document presented in court read as follows:

> STATEMENT OF MRS. NETTIE DIAMOND,
> FEBRUARY 15, 1923, 9:10 A.M.
> *My name is Nettie Diamond. I am the wife of Harry Diamond. We live at 647 Buchanan Street, Gary, Indiana. Yesterday we left our home in our Hudson sedan at about 10:30 a.m. William Armstrong, a colored boy, was driving. I had a check for $17,000 which I had obtained from the sale of Durand Motor stock. Harry wanted me to give it to him, but I refused.*

They were speaking "Jewish," Armstrong would later testify, so he didn't understand what they were saying. But after Nettie's refusal, Harry ordered Armstrong to stop the car, saying one of the chains had slipped.

"As the boy got out to look, Harry drew a gun, pressed it against my body and fired," Nettie continued.

> *The first shot went into my abdomen. How many shots he fired into me, I don't remember. He then stepped out of the car and shot some more.*

44

THE TRAGIC BETRAYAL OF NETTIE DIAMOND

I then heard Armstrong say, "I want to live. What are you committing murder for?" Harry then got back into the car and beat me over the head with a gun. Harry then drove the car to the Calumet Drug Store, East Chicago, and he said to me: "Honey, tell them the Negro shot you." What became of the $17,000 check I don't know. I make this statement knowing I am going to die.

After her statement, Nettie said a few more words about what happened in the drugstore.

"When we got there, he said to everybody that it was Armstrong, but I was conscious enough to hear him," she continued. "My husband shot me, and I hope he's punished for it."

Then turning to Cohen, Nettie said, "Anna, I can't fight anymore. Take care of my children and take care of everything."

Within moments, Nettie Diamond was dead. Her fight was over but not before she had done all that needed to be done. Her children would be taken care of by Anna and other relatives, she had signed a statement to the police and told all present that Harry was her murderer. She had also struck him from her will. It was quite a Herculean task, but Nettie did it before letting go—to the amazement of all.

DIAMOND NOT AT WIFE'S FUNERAL
—*Times*, Thursday, February 22, 1923

Harry Diamond, charged with the murder of his wife, Mrs. Nettie H. Diamond, did not attend her funeral yesterday in Chicago. The police authorities refused to permit him to leave the county jail even under heavy guard. Young Diamond told Gary police officers, who were in Crown Point Tuesday, that he had offered the county jail officials $1,000 to let him attend his wife's funeral. He also told them that he "was not crazy" and that he knew what he was doing.

FUNERAL OF MRS. DIAMOND
—*Hammond Times*, Wednesday, February 21, 1923

The funeral of Mrs. Nettie Herskovitz Diamond, which took place yesterday afternoon at Weinstein Chapel, 8556 Roosevelt Road, Chicago, was attended by a large number of relatives and friends from the Twin Cities. The only near relative of the deceased who was able to get here was a nephew from New York. Her aged mother and other near relatives were ill and unable to come.

Among the relatives and near friends from Indiana Harbor were Mr. and Mrs. Marcus Herskovitz and children, Mr. Dave Herskovitz, Mr. and Mrs. Baronoff and family, Mr. and Mrs. Morris Fishman, Mrs. E. Buchstaber, Mrs. Zimmerman and Mr. and Mrs. Kirkendorfer of Gary.

There were five machines left the Harbor in the morning with these relatives and friends and were met at the chapel by Chicago friends. There the remains laid in state and were viewed by this large body of sorrowing friends who had gathered to pay the last tribute of respect to one they had learned to love by her jovial, always looking on the bright side nature. The services were conducted by a Chicago rabbi, and the remains were laid to rest in Waldheim Cemetery in the Herskovitz family lot.

Not present were Nettie's brothers said to be in Texas, her sister and her 84-year-old seriously ill mother who was in New York City.

Several months later, when Frank Townsley responded to the prosecutor's question asking if he thought it was remarkable that Nettie retained consciousness like she did, Townsley gave the following reply: "I can't understand it myself because when I first saw she had been

vomiting at that time and vomited—oh, I presume four or five times after I first saw her, both in the drugstore and on the road to the hospital and how she ever retained her consciousness I cannot understand."

MRS. DIAMOND TOLD HOW SHE WAS KILLED: DYING WOMAN'S CHIEF THOUGHT WAS OF HER CHILDREN— ASKS FRIEND TO LOOK AFTER THEM
—*Vidette Evening Messenger*, May 29, 1923

The jury had been sent out, and the special prosecutor William McAleer and head defense attorney Joseph Conroy began battling over what could and could not be admitted as evidence.

In the courtroom with Harry looking on, Anna Cohen Fishman fixed a piercing eye on Diamond as she told of other portions of the dying woman's statements.

Throughout her testimony, Diamond was slumped in his chair, and a sickly grin was spread over his face. Now and then a worried expression seemed to find its way to his countenance.

Harry's lawyers worked furiously to keep Nettie's dying declarations from being heard by the jury.

McAleer naturally argued against it, contending that if the defense team succeeded in keeping Nettie's verbal statements out, including what she had told both her daughter Pearl and Anna Cohen Fishman in the hospital, they would go after the written statement. Loring refused to admit their testimony, as it was hearsay, but let the state use Nettie's dying declaration because she had made it knowing she was going to die.

Linn, worried Nettie's first signature might be insufficient, had told Windmueller to have her sign it again.

"She signed it twice for the reason the first time she signed it Mrs. Diamond and I thought it would be better to have her full name," Linn said in court.

And Nettie, being Nettie and just moments away from death, did her part as well.

"She raised up in her bed," Windmueller recalled, "and signed it Mrs. Nettie Diamond."

James Allen, vice-president of the Indiana Harbor National Bank, where Nettie did much of her banking, identified her signature. And so it was done. Her statement was admitted.

McAleer stood up and read Nettie's dying declaration aloud to everyone in the courtroom—and one can only imagine how damaging the dead woman's words were to Harry's case.

Loring also ruled that any statements Nettie had made in the drugstore were admissible if made while her husband was able to hear them; if he was out of range, then they could not be used as evidence.

Having failed in keeping the jury from hearing the damaging words about his client, Joseph Conroy, always resourceful, tried another track, asking if Nettie had told a connected tale or whether the officers had interrogated her, writing down her responses to their questions as they asked them.

Windmueller testified that he had taken the statement down just as Nettie said it, word for word.

"She gave verbally the entire statement," Linn told Conroy and the courtroom. "That was the way she gave it to us at the time."

"What about the different colored pens used to sign the statement," asked Conroy.

"I see that Dr. C.W. Yarrington's name is not written well. Whose pen did Miss Teresa J. Schamm sign it with?"

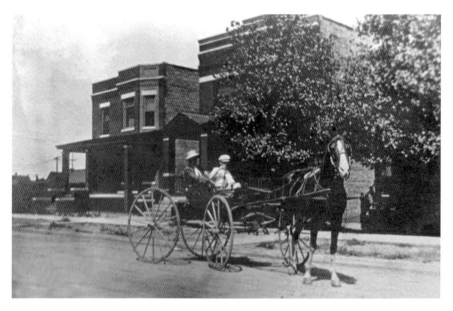

George Huish, publisher of the *Calumet News*, drives his buggy down a residential street of Indiana Harbor. With its wide-open, anything-goes atmosphere, Indiana Harbor often combined the illicit and the benevolent. Huish was revered for funding the city's softball league using money taken from slot machines. *Photo courtesy of the East Chicago Public Library.*

Here McAleer objected and was overruled, and Conroy was free to keep asking questions.

"My pen wrote the declaration," Windmueller said.

"Whose pen wrote the name of Miss Mae Gallagher?"

"The same pen."

"Whose pen wrote the name of C.W. Yarrington?

"One of the other pens in the room," replied Windmueller.

"It was not written with your pen?"

"No, sir."

"There was another pen in the room?"

"Yes, sir."

And so it went; further questioning by Conroy elicited that Dr. Craig had signed the statement with Windmueller's pen but that Linn had signed the document using a different pen. There was canny reasoning behind the use of so many different pens. Linn and Windmueller wanted to avoid any possibility of the defense implying that they had forged the signatures.

Next, Conroy pursued the medical testimony, cross-examining Dr. Townsley about the bullet fired into the back of Nettie's eye that in turn blew her eyeball out of its socket. Newspaper reporters surmised Conroy was attempting to show that Nettie was mentally unstable when she made her dying statement.

McAleer wasn't going to let that one go by. Following Conroy's cross, he stood up once again and asked Townsley two questions.

"You talked to her the next morning?"

"Yes," Townsley replied.

"Was she rational?"

"Yes."

The defense kept trying. Failing to keep out the testimony of those in the drugstore and Nettie's dying declaration, it played its next card. How could a woman shot four times and then beaten so badly with the butt of a gun that her skull had fifteen deep lacerations be of sound enough mind to accurately recount what had happened?

They called several doctors, some with rather dubious credentials, to the witness stand.

Conroy read a list of Nettie's medical injuries accurately: the bullet in the brain that couldn't be removed, the vomiting, blood loss, gunshot wounds in the abdomen, the administration of morphine, blood building up in the abdomen, the operations to sew up lacerations in the stomach and transverse colon, the inability to stop the hemorrhaging despite these procedures

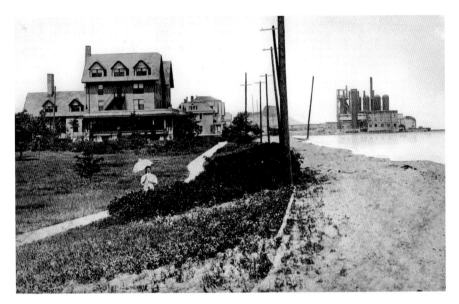

At one time, the elegant South Bay Hotel located on the shores of Lake Michigan and right around the curve of the bay from Inland Steel was the place to stay. *Photo courtesy of the Calumet Regional Archives, Indiana University.*

and the fecal matter that had scattered through her system because of the wounds. He also pointed out Nettie's state of shock after the operation, how her radial pulse was not perceptible, that the pulses from other areas were very weak and even the details of her condition when lying on the floor of the drugstore mortally wounded.

Addressing Dr. C.W. Packard, a physician and surgeon on the staff of three Gary Hospitals—Mercy, St. Mary's and St. Antonio's—Conroy asked if the doctor had an opinion about whether a person with such injuries could be of sound mind.

"I would say she was probably of unsound mind," replied Packard.

McAleer came out fighting, asking Packard if a woman being told she had a slight chance of living who asked to get the best medical care possible would be of unsound mind at that time.

"I would say possibly," was the doctor's response.

"Are not these rational statements, Doctor? McAleer fired back.

"Some of them are and some are not," he replied.

"Why not?"

"The one where she says, 'I am sane and know what I am doing.' Talking about people who are rational, they don't usually say so."

"So when she was laying on the floor and Harry said, 'I didn't do it, somebody else did it' and Nettie responded, 'No, you shot me,' wouldn't be evidence of a sound mind?" McAleer asked.

"Not necessarily," Packard responded.

And so it went, with Packard insisting that anyone who tried to say they were of sound mind probably was not. At one time, he even stated that people may be of unsound mind and still know what they are talking about.

Next up was Dr. Antonio Georgi, a physician and surgeon and the owner of Saint Antonio Hospital, where Packard was on staff. Conroy again went through his hypothetical questions. He, too, thought Nettie was most likely of unsound mind.

The physicians' testimonies were so outlandish and contrived toward the defense that the trial transcript reads like the fast-paced nonsensical comedic repartee from a Marx Brothers movie. McAleer, playing to the crowd in the courtroom, was jocular in his questioning of the doctor.

"Isn't it a fact, Dr. Georgi, that we are all more or less of unsound mind?" was McAleer's first question.

"I'd say about 99 percent of us are," was Giorgi's reply.

"When Mrs. Diamond called Cannon, the druggist, by his name and told him not to believe what Harry was saying about Armstrong shooting her, was she crazy?" asked McAleer.

"Yes."

"When she asked for the best medical care possible did that indicate she was crazy?"

"Yes."

"When she told just how she was shot by Diamond, do you think she was crazy?"

"Yes."

By this time the crowd in the courtroom and the jury were laughing. Attorney Conroy moved the court to clear the room. Loring overruled his objection, and McAleer continued.

"Do you think the physician on the job would have known more about the condition of Mrs. Diamond's mind than others?" he asked.

"He might have been mistaken," replied the doctor.

"Would you have known if you had been on the job?"

"I might have been mistaken, too."

McAleer was able to score a few more points—first that Georgi had been tried for malpractice recently, with the jury unable to reach a verdict. His attorney for the malpractice suit? Why, it was the same Joseph Conroy who had called him to the stand.

John Stephen, first general superintendent of Inland Steel, was one of many who built mansionesque homes on Lake Michigan only to realize too late that the changes in wave action and the shifting sands made maintaining a home there a precarious proposition. It didn't take long for industry to line the lake shore and the more well-to-do homes to move farther inland. *Photo courtesy of the Calumet Regional Archives, Indiana University.*

"How many malpractice suits have you been involved in?" McAleer asked.

"Three or four," came Giorgi's reply.

The physicians McAleer called to the stand painted a picture of a mortally wounded woman holding on until the last possible moment, her body failing but her mind very much intact. On the witness stand, Townsley recounted in graphic and shocking detail the damage Nettie had sustained.

Just as sobering was the testimony of C.W. Yarrington, one of the surgeons who had operated on Nettie. He spoke to her resiliency.

"Mrs. Diamond never lost consciousness except under anesthesia from the time I saw her again at which time I saw her last dying breath," said Yarrington, a graduate of the University of Michigan's medical school.

VALENTINE'S DAY DRIVE

William Armstrong was seventeen years old when he met Harry Diamond at the Majestic Garage in Gary. He was there with his friend Louis Trivel, a garage mechanic who was teaching him how to drive. Armstrong had been in his third year of high school when he received a notice that his grades weren't high enough to remain. Now he was walking to the mill each day to see if there was a job and in the

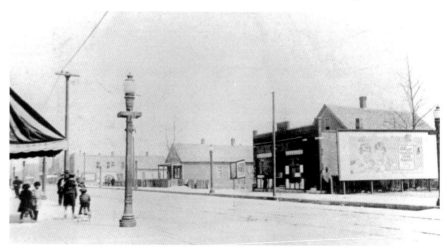

Even major roads such as Michigan, Pennsylvania and Chicago Avenues weren't paved until the 1920s. Instead, the roads were dirt—dusty in dry weather and rutted and muddy in wet weather. Sometimes logs were put down to make walking easier. *Photo courtesy of the Calumet Regional Archives, Indiana University.*

meantime helping out at the garage and working in a pool hall where he sold cigarettes and cigars.

Originally from Oklahoma, Armstrong lived with his father, a former barber who now worked in the mills, and his mother. He'd never been in trouble with the law, and from the start, the newspaper reporters liked his respectful attitude and his demeanor and believed in his innocence.

Armstrong had seen Harry a few times at the garage, but on the morning of Friday, February 9, 1923, Harry approached him and asked if he was interested in a job as a chauffeur. Armstrong said yes but that he'd like to earn ten dollars a week for the job. "You'll have to talk to my wife," Diamond said and took him home to meet Nettie, who hired him on the spot.

His job, for the six days he worked there, involved driving the Herskovitz children to their respective schools; Harry to the barbershop and on his rounds of the speakeasies; the children to the movies; Mrs. Diamond to her friend Anna's house; and Pearl, Nettie and Harry to Chicago, where Pearl took music lessons on Saturdays, Nettie shopped and Harry, well, Armstrong wasn't sure what Harry did that Saturday.

He did know that on several nights, including that first Friday night of being hired, Harry had him pick up a young woman, about twenty-two or twenty-three, Armstrong judged, at 500 Washington Street and then drive the two of them to the roadhouse Diamond owned on Ridge Road. When they got there, Diamond told him to return in a few hours. Things must have gone well with the girl because when Armstrong came back, Diamond said he'd "take care of this young lady" and dropped the chauffeur off at the hotel where Louis lived.

"What did Mr. Diamond do?" McAleer asked him during the trial.

"Mr. Diamond took the young lady and went on with the car."

"Did you ever drive him again with that young lady?"

On Sunday, Armstrong said, he'd driven Harry and the same woman—this time describing her as a "sporty woman"—to Hammond and to the park in Indiana Harbor, where Harry told him to come back about 9:30 or 10:00 p.m. Harry kept the car, and Armstrong walked to a movie theater to see a show before rejoining them. Another day, Armstrong drove Harry and the same woman to Chicago, dropping them off at Hotel Fort Dearborn. He never did learn her name. But whoever she was and whatever their relationship, she definitely wasn't the stand-by-your-man type. When the police went to look for her shortly after Nettie was shot, she had already left town.

Harold Cross, who covered the Diamond murder case for the *Lake County Times*, weaved together the differing testimonies of what did happen on the road to Indiana Harbor that fateful day.

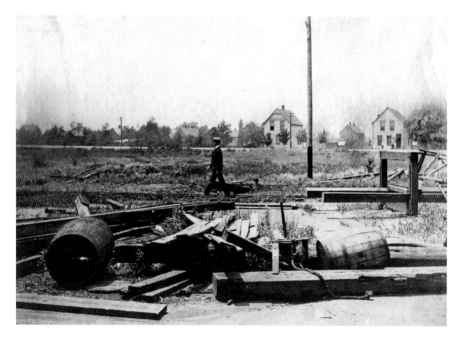

Though it seems odd, the man in this photo (which is dated 1910), all dressed up with a sporty hat on, has a reason for where he's walking. Because the land was still dunes, swale and wetlands, people usually walked along the railroad track. *Photo courtesy of the East Chicago Public Library.*

"At 10:45 a.m., the 14th day of February, this year, a Hudson sedan might have been observed traveling at a moderate rate of speed west on Fifth Avenue to Cline Avenue where it turned north towards Indiana Harbor," Cross wrote in his dramatic narrative.

Crossing the wooden bridge over the Grand Calumet River it passed the Cudahy packing plant and slackened speed, making a turn to the left on a cement road leading to East Chicago. About 200 yards west of Cline Avenue it came to a stop on the left hand side of the road. There were no houses within several blocks of the place.

The driver of the car was 17 years of age. On the right hand side in the rear seat sat a comely woman in the early forties and beside her was a young man of 24, tall and well dressed. His eyes were brown and his hair black. His overcoat was placed on the seat to the left.

A cold wind blew in from Lake Michigan. The ground was covered with snow which had melted the preceding day and frozen up overnight.

What happened next depends on whether you believe Harry Diamond or Nettie Diamond and William Armstrong. According to Armstrong, Harry had given instructions to turn off Cline Avenue onto the less-traveled Gary Road. A photo submitted by the state as Exhibit 5 shows a desolate looking dirt road winding through a barren field lined with telephone poles.

Diamond then, according to Armstrong, told him to stop because a rear tire had thrown its non-skid chain.

Not so, said Harry. He never told the chauffeur to stop. In fact, he said he'd become suspicious of Armstrong, whom he claimed knew that Nettie was carrying a large amount of cash as well as diamonds.

Why, he'd seen Armstrong signal to two men in a Ford coupe as they left Gary. Armstrong, he said, nearly ran the Hudson into a pole while he was looking back to see if the Ford was still following them.

That was enough for Harry. He asked Armstrong for the Smith and Wesson revolver he kept in the car. Armstrong told him it wasn't there because he'd taken it home to show his father.

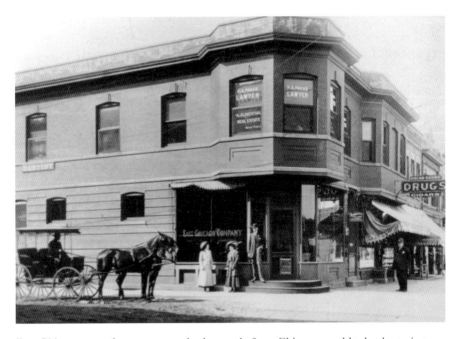

East Chicago was a boomtown, and salespeople from Chicago would take the train to the East Chicago Land Company's Indiana Harbor office in the morning, returning home at night. Nettie and Sam, and then later just Nettie, bought numerous empty lots and homes in the harbor. *Photo courtesy of the East Chicago Public Library.*

"We turned off Cline Avenue to go to East Chicago," Diamond told the jury. "We passed by the pumping station, I should judge, I don't know how far, when all of a sudden he stopped. I said, 'What's the matter?' And then I keeled over."

As he came to, Harry found himself on the floor of the car. He heard "the woman" (as he described Nettie in his testimony) moaning. He also heard someone say, "Oh, leave the rings and run" and another man saying he had the bag containing the money and the stones and that he'd see Billy the next day.

"Then I head Mrs. Diamond say, 'For God's sake, honey, help me,'" Diamond told the jury. Looking up from the floor, Harry saw Armstrong pointing the Smith and Wesson at his head. Harry reached for the gun, and the two men fought as Armstrong pounded him over the head. Somehow Harry managed to grab the gun away from Armstrong.

"I grabbed the gun out of his hand and shot over his head. He tried to throw me out of the car. He tried to get away from me and kicked the front window of the car out and pulled away from me, and upon that, Mrs. Diamond said, 'Kill him, honey, kill him.'

"I jumped past Mrs. Diamond and got in the front of the car and as he came out around from the radiator I shot at him," Diamond continued. "Then he fell down on the ground. I turned around and heard Mrs. Diamond calling for help, and then I jumped back and I beat him over the head, I beat him with the gun, and he tore away and run [*sic*] five or six feet."

Before Diamond could give chase, Nettie called out again, so he climbed back in the car. When Nettie told him she was going to die, he tried to "cheer her up."

During this part of his testimony, he became emotional, and his attorney encouraged him to take his time before continuing.

As Nettie kept repeating she was going to die, Harry told her he'd take her to a doctor soon. But Nettie had other plans—she wanted to die at the Calumet Drug Store.

"I sat her up in the seat and I kissed her and I got out of the car and got in the front and started the car," he explained. "After I started toward Calumet we got by the South Shore tracks, all of a sudden she screamed, 'Honey, kiss me. I am dying,' and slipped to the floor. I stopped the car and I got back and picked her up in my arms and both of us cried."

The loving husband, in his own words, wanted to get her to the drugstore as quickly as possible, but he also took the time to pull the car to a stop, get out, get in the backseat and wipe the blood from her mouth with his

Above: The streets were so bad in early Harbor days that grocers delivered groceries to the end of the street in wagons and then in wheelbarrows to the destination. It wasn't unusual in those early days to see oxen pulling carts down the middle of streets. *Photo courtesy of the Calumet Regional Archives, Indiana University.*

Left: Before paved roads (and even some main streets in Indiana Harbor weren't paved in the 1910s), roads were dusty in dry weather and muddy and sometimes impassable during wet weather. Oiling down dusty roads helped keep drivers and their passengers from becoming covered in a film of dirt. *Photo courtesy of the Calumet Regional Archives, Indiana University.*

handkerchief before placing her back in the seat and returning to the driver's seat.

"She kept crying, 'Honey, I'm going to die,'" Diamond testified. "She said, 'Harry, take care of the children and the baby.'"

Harry again tried to reassure his wife that she wasn't going to die. Nettie was silent for a while until he turned the car onto Chicago Avenue.

"All of a sudden she spoke up and said, 'Honey, if I die, I want you to die too. I'm not going to let you live to run around with other women. I've been jealous of you a long time and you know I love you," recalled Harry. "I'm going to say you shot me and the Negro did not shoot me."

"I said, 'No, honey, don't say I did it, tell them the chauffeur did it,'" Diamond pleaded with his wife.

Nettie insisted she didn't want to die alone; she intended to take her beloved husband with her. To do so, she would accuse him of murder.

The young women who flocked to the courtroom, listening rapturously to every word Harry said, must have thought the story romantic—a brave, handsome young man fighting a gang of thieves and murderers in order to save his wife.

Cynics might say that Harry wasted a lot of time getting his wife to a place where she could get medical attention. The drugstore was out of the way. He could have just as easily turned around and headed to the nearest hospital, which was in Gary.

Psychologists might suggest that Harry was adding emotional distance between himself and his victims. Nettie became "that woman" and "Mrs. Diamond," while he almost always used racial slurs to describe Armstrong.

When Dr. Charles Webb Yarrington talked to Nettie before operating, her story was, of course, different from the heroic one told by Harry Diamond.

"Harry said, 'Billy, your chain is off,'" Yarrington testified at the coroner's inquest. "Billy stopped the car and got out."

Harry began shooting her, wounding her several times, and then he beat her over the head with the butt of his gun, continued Yarrington, the first public school physician in Gary who later went on to private practice. Then Harry shot Billy and beat him over the head with the gun.

Astoundingly, Nettie, who was literally at death's door, remembered vividly even the minutest detail.

"While he [Billy] was on the ground, she saw Harry put a paper of some kind in Billy's jacket or tried to put it in," Yarrington said, recounting what Nettie had told him. Harry then drove her to a drugstore in East Chicago. On the way, he told her to tell the police that Billy did the shooting."

Nettie obviously would do no such thing.

As for Armstrong, his testimony varied little from Nettie's.

"Mr. Diamond was looking out the back window and I shook my head and said the chain was not off," Armstrong testified at the coroner's inquest on February 17, 1923. "About that time something was heard like a shot, and Mrs. Diamond screamed, 'Oh Harry, what did you do it for. Oh Harry, what did you do it for.' I then went to the car and asked Mr. Diamond what was the matter with Mrs. Diamond and he said 'nothing' and about this time I was shot."

The bullet entered a space just below his left temple and exited below the right eye. Armstrong fell to the ground, stunned. He remembered Nettie crying, "Billy, take that gun, take that gun."

Nettie, lying in the back of the automobile, was moaning, "Oh, Harry, why did you do it?" Blood streamed down her face, saturating her fur coat. Harry opened the rear door and jumped on the running board and, leaning into the car, began pounding Nettie with the butt of the Smith and Wesson, ignoring her screams of pain and pleas for her life.

Then he turned his attention back to Armstrong, picking up the young man, placing him in the car and thrusting something inside the chauffeur's jacket.

"Mr. Diamond beat me over the head two or three times and then went to the back seat and beat Mrs. Diamond," continued Armstrong. "I tried to play dead to keep Mr. Diamond from beating me with the pistol. Finally I decided Mr. Diamond would never hit me with the pistol again so I said, 'Mr. Diamond, don't hit me with the pistol again,' and he and I started fighting."

Coroner Edward Evans asked if Harry had said anything to Armstrong during this time.

"As he was beating me, he said, 'Goddamn you, I got you now,'" responded Armstrong.

"Had you heard any sound that would make you think the chain was loose?"

"No."

"Do you think that Diamond planned that all out?"

"Yes. When we started to Indiana Harbor and when we got to that turn, he said, 'Turn here' and she said, 'Why turn.'"

Referring to the bullet wound on the right side of his cheek, Evans asked if that was the only place Armstrong had been shot.

"That is what the X-ray said, but Mother says there are four bullet holes in my cap," Armstrong replied.

What happened next would be described by newspaper reporters as a superhuman effort. With blood gushing from his head wounds, Armstrong

raised his left foot and managed to kick Diamond in the chest, pushing him out of the car, and then scrambled out himself. His head, face and clothing were covered in blood, and as he ran east on the snow-covered road, hollering, "Murder!" he fell but then quickly pulled himself back up.

Harry ran after him—bad luck for him, very good luck for Armstrong because as the two men were running, a truck crossed the bridge on Cline Avenue. As it headed down the road toward them, Harry gave up the chase and ran back to the sedan. He jumped into the driver's seat and drove into East Chicago. Just as he approached the Calumet Drug Store on the outskirts of East Chicago, he came almost to a stop. That's when Simbolmos thought he heard a shot.

Meanwhile, the truck stopped to help Armstrong, who was shouting, "He tried to kill me, take me to a doctor!" As the truck started up again, Armstrong warned the driver not to go near the Hudson, saying, "He'll kill us."

Because the truck was slow-moving and Armstrong eager to get medical attention, the driver flagged down a passing Ford coming from the direction of Indiana Harbor. Armstrong got in and was driven to the East Chicago Illinois Telephone Company on Chicago Avenue just west of the Calumet Drug Store. To get there, they passed by the drugstore where Nettie lay dying and Harry was trying to convince her to tell everyone that Armstrong had fired the shots.

"No question in your mind that he shot her deliberately and then tried to kill you?" asked Evans one more time during the inquest.

"No," came the quick response.

Armstrong was sitting on a settee when Leo McCormick, an East Chicago traffic policeman on duty that day, walked in after receiving a call about Armstrong's condition. About the same time McCormick arrived, Harry was on his way to the East Chicago jail.

McCormick, over the defense's objection, described Armstrong's condition that Valentine's Day morning.

"His head was covered, was a pool of congealed blood and blood ran down his face and some was coming from and through his nostrils and some through his mouth," he testified under questioning by McAleer. "He had on a soft collar and a soft shirt and that was saturated with blood, which was dripping on his clothing and on the floor where he was leaning over and a large pool of blood came from this man, dripping off [his] body or from his head."

Conroy objected again and was sustained, so McAleer rephrased his question, asking McCormick what he observed upon seeing Armstrong's wounds.

"I went up to him and looked him over and on one side of his face there was a bullet, looked like a bullet came out like this, and a little lower on his cheek there was a black ring; it looked like smoke about the size of a fifty-cent piece right around here on the cheek, and in the center of that circle it looked like a hole was in there."

When Diamond arrived at the jail, he vociferously maintained his innocence, stating that Armstrong was the man who shot his wife and that he, in turn, shot the chauffeur in a gallant but ultimately futile effort to save her. He told the police to search Armstrong, and they would find a letter that would prove the chauffeur's guilt.

McCormick had already called Chief Struss to tell him what Armstrong had said. They in turn told Harry that no letter was found on the chauffeur. Harry then suggested they go out to the scene of the crime, telling the police that if they searched there they would find it. They did, in fact, find the letter, which must have fallen out of Armstrong's pocket as he ran from Harry. They also discovered Armstrong's blood-soaked hat.

But the letter didn't change their minds about Harry's culpability. After all, how could Harry have known about a letter written by Armstrong confessing to robbery unless he had played a part in its writing?

Then McAleer asked McCormick what he'd seen on Armstrong's head.

"This part of his head back here was full of congealed blood," McCormick replied. "I put my hand on his head and there were several scalp wounds back here, several different places on his head."

McAleer then, after countering several objections from Conroy, asked McCormick what the shortest and best route from Fifth Avenue in Gary to the Indiana Harbor National Bank was. McCormick responded that the quickest way was to take Fifth Avenue to Cline Avenue directly into Indiana Harbor.

"What kind of pavement has Cline Avenue?" asked McAleer.

"Cline Avenue is concrete and cement," was the reply.

"What kind of surface has Gary Avenue?" McAleer next asked, referring to the road onto which the Hudson turned instead of continuing on to Cline.

"Macadam," said McCormick, noting that the road had a spreading of Tarvia, which was a soft tar often covered with sand and rock that easily broke into pieces.

In other words, McAleer was able to show the jury that Fifth Avenue to Cline into Indiana Harbor was shorter and that the road was much better, but Harry had told Armstrong to take the very deserted, longer and rougher road instead.

FIND BLOOD SOAKED LETTER
—*Lake County Times*, February 17, 1923

Fifty feet east of the pool of blood on the road that marked the spot where the crime had been committed a police officer found a blood soaked letter addressed to the chauffeur's father. It was sealed and bore an uncanceled stamp. The letter was in the chauffeur's handwriting and read, "Dear Folks, I am leaving here with $2 or $3000 in diamonds, a brand new car and money in cash and Charlie has promised to buy the car. Your devoted son, Will."

At the coroner's inquest, Armstrong testified that he had written the letter the morning of the murder at the instruction of Diamond, who told him it was a joke on a friend.

"He asked me to write it and said it was for a Jewish boy that left home a week ago with $11 in his pocket and when his folks got that they would wonder how he got so much money."

"What did he say the boy's name was?" Edwards asked.

"Will Levy," replied Armstrong.

"Your name?"

"A. William Armstrong."

"The night before he had you address an envelope to your father?"

"A.F.J. Armstrong is my father."

"And the next morning a letter?"

"He had me write an envelope—Mr. Mitchell Levy, 836 Connecticut Street, Gary, Indiana.

Evans wanted to know what Armstrong did with the letter after he wrote it.

"I gave it to him and he put it in an envelope and said to go the post office," responded Armstrong. "And I did and he went in and then we went down to the house."

As for the envelope addressed to Armstrong's father, Diamond said he was buying an insurance policy for Armstrong and naming his father as the beneficiary. Armstrong believed the letter was the "something" Diamond had slipped into his jacket during their fight. It must have fallen out when he escaped from Diamond and was running toward the truck.

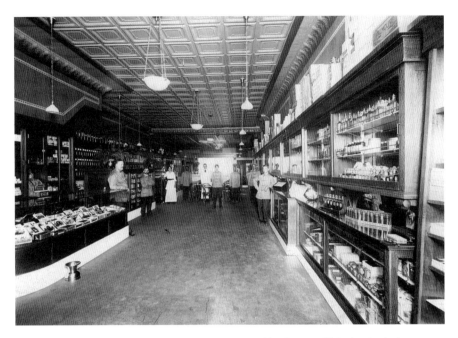

One of the several pharmacies listed as being owned by Sam and Nettie; she is the woman in the white dress standing next to the prescription counter. The man standing in the center is most likely Sam. At the time this was taken, Nettie might have been the only—or at least one of just a few—female pharmacist in the state. *Photo courtesy of the East Chicago Public Library.*

Though Nettie never saw William Armstrong again after Harry drove her to the Calumet Drug Store, leaving Armstrong at the scene of the crime, her story of the shooting as she told it to the police in her hospital room matched his perfectly. It was only Diamond's tale that sounded false.

6
THE MEN IN HER LIFE

"Are you the second husband of Nettie Diamond?" asked defense attorney Joseph Conroy.

Diamond hesitated before answering. He bit his lips and looked at the floor. Then he said in a whisper, "No, I was the fifth."

What we know about Nettie's matrimonial exploits: She had a child, most likely before 1902, named Edward Sachs, to whom she left money in her will. According to family lore, Edward was disabled—it's thought he had a withered limb—and though even her children didn't seem to know of his existence, she supported him financially, according to relatives. In every reference to Nettie before her marriage to Dr. Herskovitz, her maiden name was said to be Sachs. If that were true, then Edward would have been born out of wedlock. St. Louis Census records in 1920 show an Edward Sachs living at the City Sanitarium, though his parentage is listed as unknown. Ten years later, in 1930, he is still there. When Nettie's will was probated in the early 1930s, only the four Herskovitz children are listed. Edward's name is gone. Could that mean he had died? As for another husband, one reporter wrote that Nettie had been married for one day and then boasted she had paid him to divorce her. A Nettie and Henry J. Sachs were married on December 20, 1901, and though their divorce wasn't final until November 19, 1902, the *Evansville Courier Journal* reported that they lived together for only a short time. Henry didn't show up to finalize the divorce in Vanderburgh County Superior Court, and Nettie was granted costs. One reason for the matrimony disharmony? Henry claimed that Nettie refused to cook him even one dinner.

UNHAPPY SEQUEL TO DRUGGISTS' WEDDING
—*Pharmaceutical Era*, Volume 40, 1908

St. Louis, Oct. 3.
Louis J. Zauderer, a druggist of 2036 Carr Street, has left St. Louis without taking his wife or friends into confidence as to his plans. Mrs. Nettie Zauderer, who conducts a pharmacy at Seventeenth and Carr streets, recently sued for a divorce. Zauderer sought to get her to withdraw the suit and failing that left the city. The couple were married in New York and completed their pharmaceutical education at New York College of Pharmacy.

DIVORCE FOLLOWS MARRIAGE OF TWO PHARMACISTS
—*Pharmaceutical Era*, Volume 40, 1908

St. Louis, Dec. 12.
Mrs. Nettie D. Zauderer, druggist at 1701 Carr Street, has obtained a divorce in Circuit Judge Kinsey's court from Louis J. Zauderer, also a druggist, who formerly kept a drug store at 2036 Carr Street. They studied at the same school of pharmacy and were married in New York in 1902. She charged failure to support, abusing and drinking. He did not contest but sold his store after she filed suit and left the city. The custody of their child was awarded to her.

Louis Joshua Zauderer was born on September 28, 1883, or 1884—his tombstone has a different date than the World War II draft registration card he filled out and signed, as does his marriage certificate to Julia Lee Lacy in 1920.

Sam also owned the Red Star Pharmacy. Shown here is one of its order forms from that time period. *Photo courtesy of the East Chicago Public Library.*

A 1902 graduate of the New York College of Pharmacy, both he and Nettie had the same preceptor, Leon Solow, though she was two years behind him. (Interestingly, she didn't take his last name when in pharmacy school, graduating under the name of Sachs.) The annual catalogue for the school lists his residence as New York City. After his divorce from Nettie, he appears to have returned to New York City, where he again worked as a pharmacist. In 1929, the following notice appeared in the *National Association of Retail Druggists Journal*: "Louis J. Zauderer's Address Wanted: Information is desired relative to the whereabouts of Louis J. Zauderer, a licensed physician and registered pharmacist. He is a native of New York. At one time he was engaged in the drug business in St. Louis."

ILL, RISES FROM BED TO PLEAD AGAINST DIVORCE:
DRUGGIST IS SUED BY WIFE, ALSO A DRUGGIST WHO WED AT 15;
HER STORE HIS GIFT. OFFER $100 TO LEAVE HER, HE REFUSES
AND BEGS RECONCILIATION
—*St. Louis Post-Dispatch*, September 2, 1908

When he learned Wednesday that his young wife, who married him when she was 15 years old, and to whom he recently deeded one of his two drugstores, had filed suit for divorce, Louis J. Zauderer arose from a sick bed, hastened to her store at 1701 Carr Street and pleaded with her for a reconciliation.

Mrs. Zauderer, before his visit, declared that she and her husband could never agree and said that she intended to press her suit for freedom and the custody of her 3-year-old son Edward.

Zauderer owns a drugstore at Twenty-first and Carr streets. He says his wife's store, four blocks east, was his gift to her. It was made over to her, he says, one year ago, just before the time which names in her divorce petition as the date of the separation.

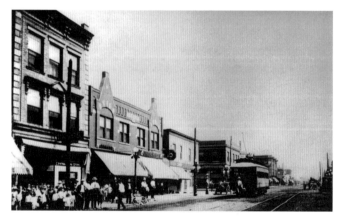

Michigan Avenue looking west. The crowd on the south side (left) is standing in front of Central Drugs, one of the pharmacies said to have been owned by Nettie and Sam at one point. *Photo courtesy of the East Chicago Public Library.*

Enlisting on September 8, 1917, to fight in World War I, in which he was a first lieutenant in the medical corps, Louis J. Zauderer was discharged on February 28, 1918, and returned to Manhattan, where records indicate that he might have married an Elvira Collin on April 8 of that same year.

By the mid-1920s, the San Francisco, California city directory has him living at 60 Taylor Street, working as a pharmacist and married to Julia Zauderer, a divorcée from Louisiana (though she wrote on her marriage application that she was widowed), having married George Foster Edwards in 1905 and divorced in 1911. They had one child, Eloise Edwards, who was around twenty-three when her mother, Julia, died in 1929. In an interesting aside—and only because we're dealing with doctors and pharmacists—it's noted on her death certificate that she died of natural causes: inflammation of the myocardium and parenchymatous of the kidney. Her stomach and urine were sent to a chemist, but no poison was found. The question is, why did they send specimens to a chemist? Was poisoning suspected?

In 1929, Louis was living in Los Angeles, where he continued working in the field of pharmacy. A few years before his death, Zauderer lists his

WIFE SUES HER SOULMATE WHEN HE WEDS RIVAL:
MRS. DORA SCHULTZ WANTS $900 FOR BOARD AND MONEY
GIVEN TO AFFINITY; PROMISED TO BE TRUE; SAYS HUSBAND
KNEW OF ATTACHMENT AND MADE NO OBJECTION
—*St. Louis Post-Dispatch*, September 14, 1909

Mrs. Dora Shultz, living with her husband, Joseph, at Blair Avenue, fell in love with Samuel Herskovitz the first time she saw him. He was tall and strong, and Mrs. Shultz says he was the "handsomest creature" she had ever seen. So great was her love for him that she took him to her home, gave [him] the best spare room in the house which she and her husband occupied, cooked his meals and darned his socks.

She did more than that. Not only did she require him to pay no board but she also advanced him money to pay his tuition as a student at the Medical College of Washington University. For three years she paid for his schooling and his books.

Mrs. Shultz says her love for Dr. Herskovitz was purely platonic and that her husband knew all about it.

The exterior of Central Drug Store located on Michigan Avenue, one of the busiest streets in Indiana Harbor. Workers coming to and from the mill might have stopped there to buy a cigar, perfume, get something to drink at the soda fountain and the like. *Photo courtesy of the East Chicago Public Library.*

address as posh-sounding 1647 Ocean Front, Santa Monica, California, a home he shared with Linda Zauderer.

When Zauderer died on April 8, 1944, he was laid to rest in an unmarked grave. On May 1, 1944, Paul A. Hatton, domiciliary officer of the Veterans Administration in Los Angeles, applied for a flat marble headstone "for the unmarked grave of a veteran to be furnished and shipped prepaid at Government expense" by railroad or otherwise to the nearest railroad station or steamship landing. The request was stamped received on May 16. His tombstone in Los Angeles does not refer to any other relatives such as a beloved wife or son.

The Child They Left Behind

Noah Zauderer was born to Nettie and Louis on July 20, 1905, in St. Louis. Though Nettie got custody of Noah, she left St. Louis with Sam Herskovitz shortly after her divorce was final, and by the time the couple settled in East Chicago in 1909, there is no mention in any of Sam's biographies of a stepson.

Pearl Herskovitz, when testifying at her mother's murder trial, was asked if she had a half-brother in St. Louis, and she replied yes, stating his age as seventeen.

"Did you ever see him?" McAleer asked Pearl about a sibling in St. Louis.

"I think I have seen him once or twice," Pearl replied.

Noah's name came up once again when reporters talked to Herschel Cannon about the young man.

"Two years ago he dropped in at the Calumet Drug Store which at the time was owned and conducted by Mrs. Diamond," the reporter writes.

She had been secretly married to Diamond in Waukegan about a year before, it is said.

At that time, W.H. Cannon, who now owns the drugstore, was acting as manager of the establishment for "Mrs. Herskovitz." The latter was out of town, and the youth waited all day for her to return. In the meantime, he told Mr. Cannon of his parentage and related the manner of his livelihood, mentioning the school he had been attending. He brought with him his birth certificate.

When Mrs. Herskovitz returned, Mr. Cannon told the youth that his mother had come and the boy went to meet her. The mother's greeting was

SUES FORMER SOUL-MATE FOR $900

Now this dream of soul-mate bliss is shattered and Tuesday Mrs. Schultz filed suit through Adolph Abbey, her lawyer, against Dr. Herskovitz for $900 representing board and lodging and the money she advanced to him to enable him to become a physician.

The petition was filed in Crown Point, Indiana, as Dr. Herskovitz is now a resident of Indiana Harbor, a small town near Chicago.

Mrs. Schultz is a small woman with flashing black eyes and a wealth of dark brown hair. She admits that her suspicion [that] Dr. Herskovitz cared for another woman caused her action in filing suit against him.

"I am interested in socialistic work to the Jewish quarter," says Mrs. Schultz to a *Post-Dispatch* reporter. "One night at a meeting I saw Sam Herskovitz. A strange feeling came over me. Here at last was my ideal. Here was the most beautiful man in the world. I sought an introduction and when he spoke to me his words thrilled me."

"He told me he was a struggling young drug clerk and that his ambition was to be a doctor, but he had no money.

"I concealed nothing from my husband. I told how strangely the young man had impressed me and how much I would like to help him. My husband consented that I bring the young man to our house and had no objections when I told him I was going to pay Sam's way through college.

"After Sam had been at [our] house for several months he and I went to my husband and told him that we loved each other but we promised him we'd never do anything wrong. It was soul-love, nothing more.

"My husband seemed to think we did right in letting him know and he never reprimanded me for loving Sam. He understands.

"I told Sam, 'I can't have you but I don't want any other woman to have you.' He promised that he would never love anyone but me and I was satisfied."

"But he forgot his promise. After he was graduated as a doctor, he left my home and went to board at the home of another woman. That woman kept a drugstore and Dr. Herskovitz would have his prescriptions filled there and I heard she gave him money to fit up an office.

"I got him away from that other woman once. I went to him and begged him to come back and board with me for nothing and he came but he didn't stay long.

"That other woman got a divorce and I heard she is now Dr. Herskovitz's wife.

"He would never have had to pay me one cent of the money I advanced him if he kept his promise to have no one but me. I thought real love was lasting but now I know it isn't."

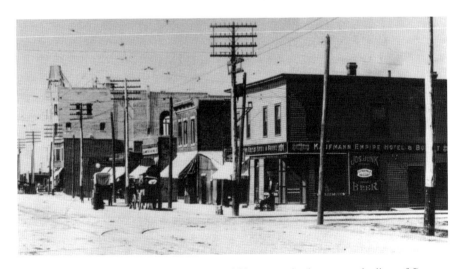

The Auditorium, at the end of the street, would have a major impact on the lives of Sam and Nettie Herskovitz. At one point, Sam had his office in the building, and it was also the site of their Red Star Pharmacy. *Photo courtesy of the East Chicago Public Library.*

*A Standard History of Lake County Indiana
and the Calumet Region*, Volume 2
by William Frederick Howat, 1915

Samuel Herskovitz was born in Romania, one of the Balkan states, February 14, 1884, a son of Joseph L. and Pearl Herskovitz. His father died in his native country, and the widowed mother, since de-ceased, came with her children to the United States. Doctor Herskovitz attended the public schools in Romania and was sixteen years old when he came to the United States in 1900. Here by hard work he continued his education, and while employed in the daytime at wages of one or two dollars a week, spent his nights in study.

Doctor Herskovitz received his professional training in the medical department of Washington University at St. Louis, from which he was graduated M.D. in 1908. After several months of practice in St. Louis, he took postgraduate work at Chicago in the diseases and treatment of the eye, ear, nose and throat, and with this thorough equipment for both general practice and his specialty, came to Indiana Harbor in March, 1909. The scope of his work soon broadened beyond the strict lines of his profession, and in 1910 he established the Calumet Drug Store, and in February, 1913, the Red Cross Pharmacy was opened under his proprietorship. These are now two of the best equipped and best known pharmacies in the city.

Doctor Herskovitz has membership in the Lake County and the state medical societies, and the American Medical Association. On October 8, 1908, he married Nettie D. Sachs of New York. Their three children are: Pearl, Joseph L., and Bernard. Doctor Herskovitz affiliates with the Independent Order of Odd Fellows, the Knights of Pythias, and

> the I.O.B.A., the Fraternal Order of Eagles, is a member of the Indiana Harbor Commercial Club, and in politics is republican. During 1912–13 he has given an important public service as secretary of the board of health of East Chicago. He is also secretary and director of the *Twin City Sentinel*. All these relations and activities indicate his prominence as one of the leading young men of affairs in the Calumet region.

not effusive, nor did she exhibit any great amount of surprise at the sight of her son, it is claimed. Without entering the drugstore, she took the boy by the arm and led him to her apartment over the store. Nobody saw him emerge, and it was surmised that he was sent away by his mother during the night. So far as is known, this was the last seen or heard of him.

Nettie, in writing her last will, left her estate to the four children she had with Sam; her infant daughter, Fay Diamond; and Edward Sach (there is no *s* at the end of his name in either her will or the estate paper), whom she described as a son "from a previous marriage."

ANCESTRY.COM

According to the New York State Census of 1905, there were eight children in the Herskovitz home—six sons and two daughters. Marco was the oldest, having been born in 1879. He most likely is Sam's brother Marcus Hershcowitz (that's how he spelled his name when practicing law in Indiana Harbor), who is listed as twenty-six years old, born on October 6, 1879. Then there were Joseph, Abe, Sam, Isadore and Jacob. It's a guess, but Isadore might likely have morphed into David by the time he arrived in Indiana Harbor.

The remaining members of the family appear to be the two sisters, Nettie (age fifteen) and Sadie (age eight), listed. Nettie most likely is Sam's sister, who is identified later in newspaper articles and census records as Etty. She and her first husband had three children and were living in

St. Louis when Sam was in medical school there. Widowed, she and her children followed Sam to Indiana Harbor, where she is listed as a midwife.

E. CHICAGO SHOCKED BY NEWS
—*Lake County Times*, April 1, 1916

East Chicago and the Calumet region were startled and grieved last night to learn of the death of Dr. Samuel Herskovitz, of Melville and Chicago Avenues, East Chicago, who ten days ago was taken to the South Shore hospital, South Chicago, suffering from gastric ulcers.

For the past eight years, the doctor has been a prominent figure in professional and political circles, with a large following of friends and admirers. He has been representative of the township trustee in East Chicago for a number of years. He had three drug stores—one at Melville and Chicago avenues, one on Cedar Street and one, the Auditorium, on Michigan Avenue.

About two years ago, the doctor was compelled to undergo an operation for ulcers and he has been in poor health ever since. Recently his condition became alarming and ten days ago he was taken to the hospital where he submitted again to the surgeon's knife. He did not recover, passing away at 6:45 p.m., Friday, March 31.

Dr. Herskovitz was born in Romania thirty-one years ago. In 1899 he came to this country, locating in New York City, where he remained for four years. He then went to St. Louis, Mo., where he entered the Washington University, graduating in medicine in 1908. Immediately he came to East Chicago where he built up an enviable and lucrative practice.

> He leaves a brother, Marcus Hershcowitz and a sister, Mrs. Hillel, 137th street, both of Indiana Harbor; a wife, Mrs. Nettie B. Herskovitz and four children, Lloyd, Bernard, Cecil and Pearl.
>
> Services will be held tomorrow at one o'clock at the residence on Chicago Avenue, Calumet. Rabbi Silver, of Chicago, officiating. The cortege will proceed by auto to Waldheim Cemetery, Chicago, where the remains will be laid to rest.

WASHINGTON UNIVERSITY MEDICAL SCHOOL, ST. LOUIS

The annual commencement was held on Thursday, May 28, 1908, when Professor William G. Spiller of the University of Pennsylvania delivered an address to the graduating class, and the chancellor of the university conferred the degree of doctor of medicine on the gentlemen. Listed among these was Samuel Herskovitz.

The inscription on Dr. Herrskovitz's tombstone in Waldheim Cemetery, Chicago, Illinois, reads:

In Memory of My Beloved
Husband
Our Father
Dr. Samuel Herskovitz
Born February 2, 1884
Died March 29, 1916
Gone but Not Forgotten

In an interesting aside, Nettie and Samuel don't lie next to each other. She is buried in Waldheim's Progressive Order of the West Section, Gate 37, Lot 2202, Row 2, Grave 4. Sam rests in the cemetery's Independent Order B'rith Abraham Section, Gate 53, Lot 1159, Row 59, Grave 3. Harry, too, is buried at Waldheim but in another section entirely.

SOL S. GOLDEN, MD

A marriage license issued by Cook County, Illinois, shows that on June 15, 1918, Nettie Herskovitz of East Chicago, Indiana, married thirty-five-year-old Sol Golden, a medical doctor practicing in Chicago and a World War I veteran. The bride listed her age as twenty-nine. Like Sam Herskovitz, Golden was Jewish and emigrated from Romania. He received his medical degree on May 20, 1913, from the University of Valparaiso Medical School. Though the university is, as the name implies, in Valparaiso, at that time, their medical school was located in Chicago. The marriage didn't last long, and by August 1918, the couple were divorcing, with Golden claiming Nettie had tried to stab him and then threatened to shoot him in front of witnesses. He also disclosed that they had only known each other about two weeks before marrying. Nettie admitted threatening to kill him, saying she would do it again and that she had kicked him out because he wanted her to work and support him. "Do you think any woman would want to be tied down to a man like that?" she asked the judge. At the time of his death at age thirty-eight on November 4, 1921, Golden is listed as single and living at 1244 North Claremont in Chicago.

HARRY DIAMOND

Harry's career arc was like a fast-moving shooting star.

He was born in Louisville on Christmas Day 1899, and his parents, Joseph and Esther Diamond, were struggling emigrants from Russia. His father's occupation in his home country was listed as peddler. The large family moved first to Michigan City and then to Gary, where Harry graduated from Emerson High School at a time when the Gary Public Schools were considered among the best in the nation. His extracurricular activities were few but included chorus, the senior play and oratorical and commercial clubs. Showing that prejudice against Jews was still common then, written under his senior photo is: "His favorite work is dodging Miss Lynch." Since there was no Miss Lynch teaching, it appears to be a reference to lynching and to the prevalence of the Ku Klux Klan, which had a strong presence in Indiana.

Hazel Swisher, also a member of the class of 1916 and editor of the yearbook's Senior Prophesy page, noted, "Another member of our class, Harry Diamond, is following his chosen vocation and is a successful business man." In the Senior Class Legacy, where bequests are made to those left behind, the

comments editor, Charlotte L. Steiner, writes a legacy indicative of the smugness and arrogance that became so obvious during his trial with the statement: "From the Diamond estate is the good opinion he has of himself."

After graduation, Harry enrolled in Valparaiso University's Law School (an undergraduate degree was not needed at that time to be admitted), but after a few months, he quit.

"There was not enough money in law so I took a job as a laborer in several places," he testified under examination by his attorney.

One of these jobs was in a chemical laboratory for a steel plant, but suffering from what he termed "fits," he left the job, going to the Mayo Clinic in Rochester, Minnesota, for treatment for epilepsy.

Inland Steel, a behemoth steel company located on the shores of Lake Michigan, was one of the major transformers of this piece of wild and inhospitable dune land into a center for manufacturing. *Photo courtesy of the East Chicago Public Library.*

"In April 1919, I began work for the Standard Bottling Works at 3617 Ivy Street," he told the court.

> *There I began to make money by taking orders for whiskey. I saved $1,300 the first year and extended my operations so that in 1921 I made $40,000 on the sale of whiskey and near beer which I sold for real beer.*
>
> *Two Italians, Dominic Miranda and Joe La Sarrie, acted as my agents in this and paid me a commission. In 1921, I acquired 573 gallons of alcohol from the government on permit to make extracts. I sold 3700 gallons of extract in one year and this contained the alcohol I got from the government. I sold this to the Exol Company in Chicago.*

Business was booming. Standard sold soft drinks and manufactured extracts for ice cream parlors, confectioners and peddlers. And they took orders for whiskey, which they made and then slapped labels on—whatever kind of label they wanted, Harry explained—selling it for $125 a case.

Harry was smart enough to not drink his own products. He claimed, and for once there was no reason not to believe him, that he didn't consume alcohol. For all his arrests, none was for drunkenness.

Though the Volstead Act, also known as Prohibition, didn't go into effect until July 1, 1919, Indiana had jumped the gun, and its dry law started at midnight on April 2, 1918. By the following day, according to Powell A. Moore in his book *The Calumet Region: Indiana's Last Frontier*, a large number of saloonkeepers had gone into the "soft drink" business. Two weeks later, a wagon loaded with forty gallons of whiskey was seized in East Chicago en route from Chicago to a justice of the peace in Gary.

If you didn't mind breaking the law, the profits were phenomenal. Harry was soon making $40,000 tax-free a year.

But Harry was just one of many in the right place at the right time and willing to take the risk. Moore tells the story of an East Chicago undertaker who transported booze in his hearses and ambulances. In 1922, an immigrant woman, poor two years earlier when she had first arrived in the United States, purchased $11,000 in traveler's checks with money she made operating a still in her kitchen. Smart enough to get out when the going was good, she returned to her native country a very wealthy woman indeed.

There was booze galore to buy and sell. Indiana Harbor, located at the tip of the southwest shoreline of Lake Michigan, was a global terminal. No prohibition law existed in Canada, so it was easy for American bootleggers to have booze shipped over by boat. All it took was a willing agent at the East Chicago Dock Terminal to look the other way when the cases of alcohol were unloaded and driven away.

People hated the law and wanted booze, creating a market for entrepreneurs like Harry. A proliferation of soda pop shops opened in most cities, including East Chicago, Hammond and Gary. The shops actually did sell soda pop, at least up front. The hard stuff was available in the rear of the front parlor, usually behind a curtain or partition. According to an issue of the *Gary Evening Post* dated May 23, 1921, more than two hundred shops like these could be found in Gary alone.

On the stand, Harry enumerated the times he'd been arrested and charged with violating the Volstead Act. The list was indeed long. In 1921, he was arrested in Crown Point, the seat of Lake County, and tried in the

criminal courts on a charge of stealing ten gallons of alcohol from a truck. He was acquitted.

That same year, Prohibition agents, acting on information that they would find Diamond's employees pouring liquor into pop bottles, raided the Standard Bottling Works in Indiana Harbor. Someone called Diamond first, most likely one of the local policeman making the raid, and no alcohol was found. That same year, writes Powell, the chief of police and a police captain in East Chicago were sentenced to serve two years in a federal prison for alleged conspiracy to violate the Prohibition laws. The feds testified at the trial that the East Chicago police wouldn't cooperate with them in enforcing the laws and even notified the bootleggers when federal officers planned a raid.

Local newspapers also reported that Diamond was suspected of taking part in a robbery at a Hammond distilling company and making off with thousands of dollars' worth of grain alcohol. George Weeks, a Prohibition enforcement officer for the district at that time, worked with other federal agents and found empty grain alcohol cans from the Hammond distillery discarded at the foot of an embankment, just yards away from Diamond's bottling plant. A court affidavit charges that "Harry Diamond feloniously and burglariously, in the night time, [did] break and enter into the office, storehouse and business house of The Excel Company." The incident occurred in early February 1922, and Harry was arrested. Nettie bailed him out, pledging property valued at $5,000 to pay the $3,000 bond to get him out of the Crown Point jail. She should have left him there, for the following year he'd be back after being charged with her murder. On March 21, 1922, after a two-day trial, Harry was found not guilty.

For some reason, getting off wasn't enough. Harry wanted to make sure that he was seen as a legitimate businessman, so he frequently stopped by Weeks's office to profess his innocence. Needless to say, no one seemed to be fooled.

When federal agents arrested a large number of bootleggers, Harry was the bondsman for one of them, a man named Lester Cahn, the owner of a speakeasy on Washington Street in Gary. Having put up $2,000 for bail money, as the case continued to drag on, Diamond petitioned the court to get his money back—with no luck.

There was also evidence (but no conviction) that Diamond was selling liquor to other bootleggers, who in turn sold it to some of Hammond's most prominent citizens. One month before the murder, the East Chicago police questioned Harry about a hold-up on Cline Avenue. And the day before he

shot his wife, Diamond was in court on a speeding violation and fined fifty dollars and court costs.

It was becoming apparent to Harry that his luck was running out, so, as he told the court, he'd decided to become less "prominent." It was time to diversify.

Investing $6,000 to become one-third owner and silent partner in a roadhouse on Ridge Road in Hobart just south of the Gary city limits, Harry did the bookkeeping and worked as a cashier. There were two other partners in the business, though Harry said he couldn't remember the name of one of them. But he did know Matt Buconich.

They would fall out later, as thieves will do. Before Nettie's murder, the roadhouse was in receivership, and Harry was claiming that Buconich was dissipating the funds by keeping too many of the girl entertainers on the payroll. The roadhouse was closed down by the authorities, and the case moved to Judge Loring's court. It never went to trial, as soon after Harry was charged with murder.

When Harry first bought into the roadhouse, Matt Buconich seemed like his kind of guy. A few years older, Buconich was definitely a bad boy just like Harry. Matt and his brother were part of the Gary Liquor Conspiracy and were arrested, along with about seventy-five alcohol entrepreneurs, including Gary's mayor Roswell Johnson. It was such a sensational case that it found its way into newspapers across the United States. The March 31, 1923 issue of the *Fayetteville Democrat* in Fayetteville, Arkansas, ran a long story about it on the front page.

What a racket it was, too. Not only were the bootleggers selling their wares, but the government was also able to prove that the defendants—a group that comprised city judges, sheriffs and prosecutors, as well as a number of policemen and constables—were collecting weekly payoffs. The confiscated liquor wasn't poured down the drain; rather, they sold it themselves.

The star witness in the trial—Caspari Monti, king of Gary's Little Italy, who agreed to testify for the state—refused government protection, saying he could take care of himself. A miscalculation to say the least. While walking down the street in Gary, Monti was shot by two men carrying sawed-off shotguns. Several other witnesses were also attacked.

Enraged at the loss of a star witness, District Attorney Homer Elliott threw a network of armed guards and federal agents around the witnesses and throughout the corridors and courtrooms of the Indianapolis Federal Court, where the trial was being held.

Ethnic groups would open businesses, often employing many of their family members and living next to or above their stores. *Photo courtesy of the East Chicago Public Library.*

Monti had signed an affidavit naming the seventy-five people involved in the conspiracy. Though a few minor players were acquitted, the rest were found guilty, including Matt Buconich. He and his brother Steve were charged with operating a roadhouse—not the one he and Harry owned—on Eleventh Street in Gary. Matt and seven others filed an appeal that made its way to the United States Supreme Court saying that published statements by the public prosecutor and the number of defendants rendered a fair decision impossible. They were turned down in March 1925.

By then, Harry would be dead—the first man to receive a death sentence in Porter County since 1837.

Buconich would get out of prison and soon find himself in trouble with the law again.

"Buconich's Resort Center of Interest in Two Stories Police Accused," read the headline in the *Vidette Messenger*. "Chicago's red light district got in the lime light again yesterday as the result of charges published in a Chicago evening paper to the effect the 52 alleged disorderly saloons in South Chicago are paying $10 weekly for police protection."

One of Buconich's bartenders turned witness after being charged, along with others, of running a disorderly resort. But it got worse. They also were charged with enticing and harboring fourteen-year-old Rosie Kroll. When Rosie didn't appear to testify a second time against Matt Buconich, Pearl Buconich, Steve Buconich, Michael Frank, May Stanck and Gertie Kroll, the judge, believing that Rosie's disappearance was suspicious, ordered the police to secure evidence of who was guilty of having gotten her out of the way.

Harry's roadhouse didn't just sell booze. "Keep girls there?" McAleer asked Harry on the stand.

"We had entertainers."

"How many?"

"I have no recollection."

"You have seen them there, haven't you?"

"Yes."

"What is the most you ever saw there?"

"Half dozen or eight."

This photo of the interior of a hardware store in Indiana Harbor in the early 1900s gives an idea of the shops Nettie and her family would have visited. *Photo courtesy of the East Chicago Public Library.*

Then there were the diamonds.

"About a year ago I got acquainted with some people in Chicago; they were dealing in stones, and I went into negotiations with them," Harry told the court under Conroy's questioning. "I was going there and purchasing diamonds and selling them to various people and at various times."

He'd started selling stones in June 1922 just before baby Fay was born and made about $20,000 a month, he testified.

Abe Ottenheimer, an East Chicago attorney as well as a director and an officer at the American State Bank in East Chicago, met with Harry on February 13, the day before the shooting. The two discussed two notes that Nettie had signed. One, for $2,000, was due the next day, and another for the same amount was due on January 23, 1923.

But there was other business to talk about as well. Harry told Ottenheimer he'd picked up three very good diamonds from a broker at a bargain price and would bring them over when he came with Nettie to pay off the notes.

When he was questioned about whether Nettie knew about the diamonds, Harry was vague, testifying one day that she didn't help him in his liquor business and the next day that she did. She also accompanied him, he told the court, on a Saturday when Pearl had music lessons in Chicago. Nettie would do some shopping at the Fair Department store, but they also took a side trip to meet with diamond "brokers."

"Where did you meet the diamond thieves?" McAleer asked Harry on the stand.

"At the Morrison Hotel and the Sherman House," Harry replied, mentioning two Chicago hotels. But sometimes the men came to him as well. "I would buy $1,000 worth of diamonds. I would sell them and get the money. I was purchasing stones and sometimes I would make six or seven turns in a day."

"How long did you deal with the diamond thieves?" asked McAleer.

"I didn't say they were thieves." Harry objected to the word, though that was the first time he did so.

"You would not buy anything from a thief?" McAleer questioned.

"If I had knowledge, I would not," Harry responded, though it's doubtful that many in the courtroom believed him.

It was interesting that on the stand, when talking about his businesses, Harry seemed almost proud of his acumen despite its illegality. When McAleer asked if he paid taxes on his profits, he said no and cheerfully acknowledged that he'd committed perjury by doing so.

"If you got to report where the money come from, it was safety first," he told the courtroom.

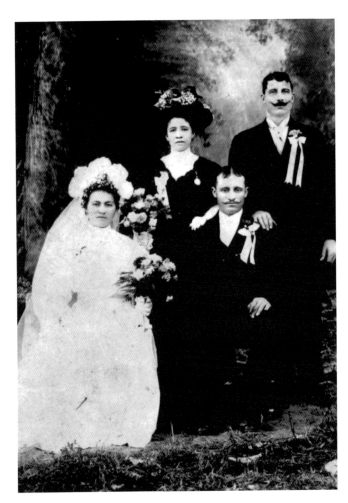

Sam and Nettie were both of Romanian descent. In this 1908 photo are two Romanian immigrants, Jon Simon and Antonia Vulcu Simon, who met in Indiana Harbor on their wedding day. *Photo courtesy of the Simon family.*

Why did Harry admit his many transgressions? It appears his defense team wanted to show that Harry didn't need Nettie's money. This legal strategy was a double-edged sword. Yes, money flowed in from his enterprises, but it also proved that he was a man who did whatever it took to make a buck—whether it was writing bad checks, selling illegal goods, running a brothel, stealing alcohol or fencing diamonds. The arrests and Nettie changing her will seemed to indicate his business career was cratering.

Harry's super nova career and his marriage to wealth were both arcing back to earth. And he was scared.

7
WHAT'S MINE IS MINE

A s quoted in the Indiana State Supreme Court trial transcript, H.J. Gillman of New York Life Insurance Company, a witness for the defense, was examined by Mr. McAleer as follows:

"What is your business?"

"Life insurance agent?"

"How long have you been a life insurance agent?"

"Since 1916."

"Do you know Harry Diamond, the defendant in this case?"

"Yes."

"How long have you known him?"

"Approximately five years."

"About the date you have mentioned you may state whether or not you had a conversation with Harry Diamond about life insurance."

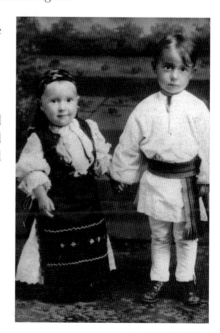

The Romanians, who at one time were one of the dominant ethnic groups in Indiana Harbor, had their own social groups in which students often dressed in traditional garb. This photo shows Mary and Dan Simon around the mid-1910s. *Photo courtesy of the Simon family.*

EXHIBIT No. 6
ANTENUPTIAL AGREEMENT
INDIANA STATE SUPREME COURT
TRIAL TRANSCRIPT

This agreement made this 29th day of January, A.D. 1920, between Harry H. Diamond of Gary, Indiana, of the one part, and Nettie D. Herskovitz of Chicago, Indiana, of the other part, witnesseth

Whereas, a marriage is intended to be solemn lies between the parties here too, and in view of the fact that after their marriage, in the absence of any agreement to the contrary, their legal relations and powers as to property may be other than in their present domicile by reasons of some change therein.

Now therefore, each of the parties hereto declares it to be their respective desire that, during their married life, each of them shall be and continue completely independent of the other so far as the enjoyment and disposal of property is concerned, whether owned by either of them at the commencement of the marriage or a crime to them during their married life. Each hereby agrees with the other that so far as it is legally possible all property belong to either of them at marriage, or coming to them subsequently during their married life, shall be enjoyed by him or her to whom it comes, and shall be subject to his or her disposition as his or her separate property in the same manner as if the proposed marriage has never taken place.

It is further agreed between the parties hereto that this agreement is interpreted to mean that the said Nettie D. Herskovitz shall be liable for any of the debts or obligations of Harry H. Diamond existing at the time of the making of this agreement or which he may incur in

the future and furthermore the said Harry H. Diamond hereby agrees that the said Nettie D. Herskovitz may sell, transfer, convey or assign any or all of her property, both real and personal, of whatsoever nature and wheresoever situated without his consent or signature and the such transfer, sale, conveyance or assignment will not be questioned or that no interest in such property shall be claimed by him now or at future period or by his heirs, assigns, executors or administrators.

WITNESS the hands and seals of the parties the day year above written,

[Signed] Harry H. Diamond [SEAL]
[Signed] Nettie D. Herskovitz [SEAL]

Nettie Sachs (not Herskovitz) married Harry Diamond the following day. The bride gave her age as twenty-three.

STATE OF ILLINOIS
COUNTY OF COOK

This 29th day of January, A.D. 1920, appeared before me, Florence De Boer, a Notary Public in and for said County in the State aforesaid, Harry H. Diamond and Nettie D. Herskovitz personally known to me the same persons whose names are subscribed to the foregoing instrument, and acknowledged that they signed, sealed and delivered the said instrument as their free and voluntary act for the use and purpose therein set forth.

Given under my hand and notarial seal this 29th day of January, A.D. 1920.

[Signed] Florence De Boer
Notary Public

"On the date in question, possibly a few days prior to that he came to me and wanted to take $25,000 on his life."

"On his wife?"

"On his life—his wife."

"Who was to be the beneficiary of his wife's policy?"

At this point during McAleer's questioning of Gilman, Conroy objected, saying it was immaterial. Loring didn't agree, and the objection was overruled.

Conroy would object several more times, but he couldn't stop McAleer from getting the information out. Diamond wanted to be the beneficiary of Nettie's policy for $25,000, but she wanted her children to get the insurance money instead.

Gilman met with the Diamonds at their home on December 12, 1922. After the applications were made, Harry called him two or three times to check on whether the policy had been approved.

THE KLAN COMES TO INDIANA

THE KLAN MARCHES IN NORTHWEST INDIANA:
20,000 PEOPLE IN VALPARAISO ON KLAN DAY
—Valparaiso Evening Messenger, May 21, 1923

S aturday was a banner day for the Ku Klux Klan organization," read the lead line in Valparaiso's evening paper about how special trains and hundreds of automobiles brought Klan members from all over, including Chicago, Indianapolis and Logansport, to what was at the time a small rural town southeast of East Chicago. "The airplane played its part also as a means of transportation and brought 'The Old Man' who delivered the principal address of the day from Indianapolis."

The Old Man was D.C. Stephenson, who had worked as a printer and salesman before he found a way to make a living riling up hatred. Born in Oklahoma, he at one time preached socialism before becoming a Democrat. Marrying and deserting several wives, Stephenson moved to Evansville, Indiana, got work in the coal business and, after changing political affiliations again, became a Republican and a member of the Klan. He had a gift for showmanship, was a fiery orator and swiftly rose to the top of the Indiana KKK. As crowds gathered for his arrival, they heard the sound of his cream-white airplane as it swooped down from the sky and watched as the Old Man stepped into view. With his hate-filled, fear-mongering speeches, Stephenson incited those gathered to hear his vile accusations against blacks, Jews and Catholics, as well as the Eastern

Europeans who crowded into cities like Gary and East Chicago to labor in the mills. Passions inflamed, Stephenson climbed into a waiting car and sped away.

There was money to be made peddling hatred, and Stephenson was raking it in. By performing these types of stunts, he not only amassed increased Klan membership in Indiana but also earned loads of cash for himself. Identifying with Napoleon (he kept a bust of the French emperor on his desk), Stephenson owned a city mansion and summer home as well as a yacht.

Despite—or maybe because—of Jews' success in businesses, there was anti-Semitism in parts of Northwest Indiana. In his book *Indiana Jewish History: The Jewish History of the Indiana Dunes Country, 1830–1950*, published by the Indiana Jewish Historical Society, author Trent D. Pendley recounts that when Joseph L. Abrahamson, an immigrant from Poletsk, Russia, attempted to buy a house on Beecher Street in Hammond near his auto dealership on Calumet Avenue, a petition circulated to keep his family out of what was largely a German and Irish neighborhood. Alas, the drive failed when the homeowner's wife sold out to Abrahamson to spite her husband, who was suing for divorce.

According to Pendley, almost a half million Hoosiers belonged to the Ku Klux Klan during the 1920s, and after January 12, 1925, when Ed Jackson became the state's governor, the racist organization briefly ruled Indiana. Right wing women founded the Women of the Ku Klux Klan (WKKK), demanding, as their male brethren did, the supremacy of white, native-born Protestants and opposing immigration, racial equality, Jewish-owned businesses and parochial schools. It was the only way, they believed, to preserve family life and protect women and children from moral decay. No thought seems to have been given to protecting the families of the maligned groups.

Stephenson's downfall came that same year in a way that typified the moral decay of their Klan's leader. Traveling by railroad to the Calumet region in March, he forced an Indianapolis woman to accompany him and battered and brutally raped her. Disembarking in Hammond, his victim attempted suicide at the Indiana Hotel and later died of her injuries. Stephenson was convicted and sent to prison (so was Governor Jackson), and the popularity of the KKK, so-called defender of women, plummeted.

Though it seems strange that Northwest Indiana, with its large influx of everything the Klan hated—immigrants, Jews, Catholics and African Americans—became a breeding ground for the organization, it was popular

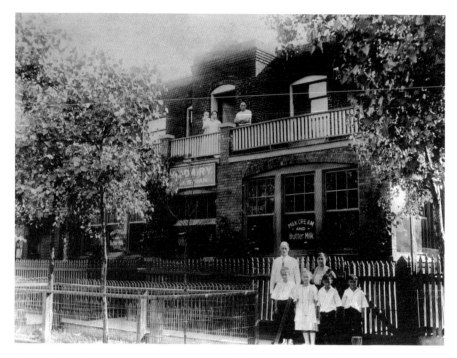

It's said that Inland Steel imported hundreds of Romanians to work in the mill. Jon Simon did so, able to walk to work from his home on Pennsylvania Avenue. He also saved enough to open the Indiana Harbor Dairy. Dan Simon (second from right) would become superintendent of East Chicago Public Schools. *Photo courtesy of the Simon family.*

in the area's rural and all-white areas. In cities like East Chicago and Gary, with their diverse cultures, the Klan's histrionics had little impact. The two largest newspapers in Northwest Indiana, the *Hammond Times* and the *Gary Post Tribune*, condemned the Klan at the zenith of its popularity, despite its editorial staff receiving death threats.

Many members of the Klan were for the most part not dangerous; they were simply joiners of a popular social scene that was overtly bigoted in its mission, says Pendley.

But that was of little solace to Harry Diamond, locked in the Porter County jail on the day of the huge Klan rally. Though the Diamond case and the Klan just tangentially intersected, the two big stories in the *Valparaiso Evening Messenger* on May 21 were about the Diamond jury selection and the Klan's twenty-thousand-person march and cross burning in Valparaiso. On the same day, the *Lake County Times* ran an article with the subtitle "Prisoner Nervous During Klan Meet and Calls for Sheriff," recounting how Diamond, the only prisoner in the Porter County jail on

CLEMENS IN DENIAL
—Lake County Times, Monday, June 18, 1923

My name was published in a certain paper that was on sale Saturday night, June the 16th of the streets of Hammond as being a member of the Ku Klux Klan. I wish to deny the truth of this statement as I am not a member, neither have I ever been a member. I have never petitioned for membership, have never seen a petition or signed. I will give $500 for charity to any cause that a Jewish and Catholic committee may elect if it can be proven that I am or have ever been a member of this organization.
Signed Geo. C. Clemens

GARY KLAN GATHERING FORBIDDEN
—Hammond Times, June 20, 1923

Mayor R.O. Johnson of Gary will not permit any Ku Klux Klan parades or public gatherings as long as he is mayor of Gary.

He made that plain to a representative of the Klan yesterday when an attempt was made by members of the Klan to get permission from the mayor to hold a public meeting in the city.

the day of Klan rally, upon observing the Klansmen march back and forth past the jail, became nervous and requested that the sheriff spend the afternoon and night with him in his cell.

DRIVING MR. DIAMOND

The first night that Armstrong worked for Diamond, he took his employer to a clandestine meeting with the girl he described as heavily painted (he never did learn her name) and was admonished by Harry to not to say anything about it to Mrs. Diamond. Two days later, he drove Diamond and the girl to Hammond. Diamond and the girl got out of the car, returning several hours later. The following day, Armstrong drove them to the Fort

ARMSTRONG TELLS OF DIAMOND'S LOVE AFFAIR: DROVE LOVERS
ON CLANDESTINE TRIPS TO HAMMOND AND CHICAGO
—*Lake County Times*, Friday May 25, 1923

An illicit love affair with a girl who lived in an apartment house on the 500 block of Washington Street, Gary, was supplied as possible motive for the desire of Harry Diamond to rid himself of his wife, 18 years his senior, and in the testimony of William Armstrong, 17-year-old chauffeur, who is a witness in the killing of Mrs. Nettie Herskovitz Diamond today remained unshaken after three hours of grueling cross examination.

Dearborn hotel in Chicago and then waited three hours for their return. Again he was told not to say a word.

The newspapers reported that the state was seeking to show that Diamond, infatuated with the girl, wanted to get rid of his wife and planned on murdering Armstrong to cover up his crime.

Armstrong made an excellent impression on the stand. He described Diamond's movements for the five days before the murder in three hours of direct examination followed by four hours of cross-examination.

"He stood up under the ordeal without flinching evading every trap laid for him by the defense," wrote a *Lake County Times* reporter. "A few minutes before 5:00 last evening he appeared to be wore out and Attorney Joseph Conroy for the defense himself suggested adjournment, saying the boy is very tired."

Conroy wasn't always so accommodating. At one time during the cross-examination, Conroy questioned Armstrong in a very sharp tone of voice, and special prosecutor McAleer objected.

"That's not fair," he said. "Don't shout at the boy."

Judge Loring sustained McAleer's objection.

The jury liked Armstrong, listening intently to his testimony, and when he met the questions of the attorney for the defense with apt replies, the jurors smiled sympathetically. Onlookers liked him as well. The talk after court was adjourned among the reporters and those attending the trial centered on Armstrong and how he had been a wonderful witness and appeared to be a very bright, nice young man.

It was not a good sign for the defense.

It's interesting to take a step back and examine the era when the trial was taking place. Women had won the right to vote just a few years earlier, but there were no women on the jury, which was composed mostly of area farmers. Armstrong was African American; Harry was a good-looking, well-poised white man. There were areas of Northwest Indiana as well as the entire state where the Ku Klux Klan was strong. The word "colored" was still used at that time and was not considered derogatory but descriptive. Other racial epitaphs were not considered proper. In the newspaper stories, reporters used the word "colored" if they felt the need to describe Armstrong. The only one who was ever quoted as using the horrid pejorative "nigger" was Harry.

There were still probably places in the United States where Armstrong, no matter his innocence, would have been convicted on the shaky testimony of such a person as Harry just because of his race. Nothing in the newspapers or police testimony indicates that Armstrong was ever a suspect. In Northwest Indiana, even in rural Porter County, suspicion rested on Harry. From the

The Romanian culture was so strong in the early part of the twentieth century in East Chicago that a Romanian school was held during the summer for students. It began as soon as the local public schools broke for the summer. *Photo courtesy of the Simon family.*

beginning, if there were favorites, it was the young William Armstrong, who was "the fair-haired boy." Pearl Herskovitz also garnered much admiration for her maturity and strength. It is heartening, almost a century later, to know the sensibilities of the citizens were fair and honest when it came to race

DIAMOND DEFENSE TO BE GANG WHO KILLED AND ROBBED THE WOMAN: THIS PHASE, HOWEVER, WILL NOT TALLY WITH STORY TOLD BY DIAMOND RIGHT AFTER THE SHOOTING
—*Vidette Evening Messenger*, Saturday, June 5, 1923

Harry's plans had hinged on leaving both his wife and Armstrong dead at the scene.

When that didn't happen, Harry needed to come up with a different explanation. Unfortunately, he seemed to be test marketing too many and then contradicting himself.

The newspapers at the time compared the murder plot as similar to the Carl Wanderer case.

Playwright and novelist Ben Hecht was a newspaperman for the *Chicago Journal* and is credited with breaking the city's famed Case of the Ragged Stranger, in which pregnant Ruth Wanderer was shot by a ragged stranger as she and her husband were returning from a movie on the evening of June 21, 1920. Her husband, Carl, told the police that he used the Colt .45 service automatic he carried when in the army during World War I to shoot the attacker. Fourteen shots were fired, and both Ruth Wanderer and the ragged stranger were found dead. Carl was unscathed. While the public celebrated Wanderer as a hero, both Hecht and his good friend Charles MacArthur, a reporter for the *Chicago Examiner*, doubted the story. MacArthur was able to discover that the gun supposedly used by the "ragged stranger" had been given to Wanderer by his cousin. Hecht, befriending Wanderer, found letters Wanderer had written to a male lover.

Transylvanian Hall was located on Pennsylvania Avenue at Washington and was one of many ethnic social centers. By 1920, when this photo was taken, some eight hundred Romanians lived in the Twin Cities, most of them in Indiana Harbor. By 1930, one of every ten foreign-born citizens in the Twin Cities was Romanian. *Photo courtesy of the East Chicago Public Library.*

Confronted, Wanderer admitted how he had duped a man he met in a skid row bar into waiting for him. When Wanderer and his wife arrived at the designated spot, he pulled out two guns and shot both his wife and the man from skid row. Wanderer went to the gallows; Hecht went on to become a legendary screenwriter with such credits as the original *Scarface*, *His Girl Friday* and *The Front Page*, sometimes in collaboration with MacArthur.

Though the ragged stranger had died, Armstrong was very much alive, and all Conroy could do was try to implicate him and a group of thugs in the robbery and murder.

"Young man," asked Conroy, "what is the name of any colored man that passed you when you were down 5th Avenue before you came to Cline Avenue?"

"I didn't meet any colored man from 5th Avenue to Cline Avenue," replied Armstrong.

"Will you tell this jury what colored man was driving the Ford coupe, if there was any?" asked Conroy.

"There was not any," Armstrong started to reply, but Conroy cut him off.

"A car that passed you and your Hudson sedan that you were driving for the Diamonds near Ambridge [a west-side Gary neighborhood]," said Conroy.

"What day is that you are speaking about?"

"A colored man on Wednesday, February 14th, going out there at the time this woman was shot."

"I didn't meet any colored man with a Ford sedan," replied Armstrong. "I didn't meet any colored man of any kind."

"Will you answer the question?" demanded Conroy. "Did you meet anyone?"

"No, sir."

"The Hudson is a left-hand drive is it not?" Conroy later asked the chauffeur.

"Yes."

"Four doors and a seat that was clear across the front?"

"Yes."

"A seven passenger or a five passenger?"

"Yes, sir."

"Room for two extra seats to be pulled out behind?"

"Yes, it has."

Conroy then asked tedious questions such as which direction the car was facing when Armstrong dropped lunches for three of the Herskovitz children at their school and what the condition of the street was like in front of the school. Then he returned to the mysterious Ford and those inside it.

Though the KKK didn't make inroads in diverse, multi-cultural Indiana Harbor, the rural white sections of Lake County saw a lot of Klan activity. *Photo courtesy of the Calumet Regional Archives, Indiana University.*

"Was there any Ford coupe that you know of that you gave any sign or signal to or recognized passing, going east at the schoolhouse when your car was stopped, as you have stated, on the left-hand side of the street?"

"I didn't see any."

Conroy also suggested that higher-ups in the Gary Police Department were collaborating with Armstrong. He went on, saying that the leader of the alleged bandit gang was Louis Trivel, a friend of William's who worked at the Majestic Garage. Conroy believed that Trivel exercised a sinister influence upon the young chauffeur.

Conroy never explained why the top brass of the Gary Police Department would conspire with a seventeen-year-old kid to railroad Harry Diamond.

But a police conspiracy in cahoots with a gang of young boys was not the only defense Harry's team of lawyers presented. There was, of course, his epilepsy. His defense lawyers called as a witness Dr. E.L. Schaible of Gary, who was Harry Diamond's personal physician and one of the doctors who treated him for epilepsy.

DIAMOND GUARD IS DOUBLED: DRUNKEN MAN FOUND PERFECTLY
SOBER HOLDS GABFEST WITH PRISONER
—Lake County Times, Wednesday, May 23, 1923

Guard over Harry Diamond, an East Chicago man on trial here for the murder of his wife, was doubled last night after Sherriff William Pennington had forestalled what is believed to have been the preliminary move towards an attempt at jail breaking.

Diamond laughs at the sheriff's precautions.

"He wasn't any friend of mine," said Diamond. "I think it was a game the state was playing. They sent him in there today to gain my confidence thinking I might make some damaging admissions that would be used against me. He didn't learn anything."

OFFICIALS ARE TAKING NO CHANCES: HE OVERDID HIS ACT

"Yesterday afternoon a young man alighted from the Gary interurban car. He was ostensibly drunk—very drunk. In fact he was so drunk that he almost overdid it. He staggered along the street until the police picked him up and took care of him. He was placed into jail apparently almost unconscious."

Diamond was brought to the jail from the court room at about the same time.

"A short time later Deputy Sheriff LeFrance made a quiet inspection of the county's two prisoners. He was surprised to see Diamond and the young drunk in earnest conversation. He broke up the chat and informed the sheriff. Mr. Pennington decided that the intoxication was all a bluff and threw the fellow out. His movements are being checked by officers."

McAleer quickly filed an objection.

"This testimony should not be permitted," he said. "In trying to get such testimony, Conroy is changing horses in the middle of the stream. He never mentioned a thing about fits going to play a prominent part in this trial."

No matter the testimony, Harry continued to be confident.

"I don't feel as though I have anything to fear relative to the outcome of the trial," Diamond told reporters. "I did not kill my wife, and I believe I will be able to prove it."

But it appears Diamond had a backup plan: a jailbreak.

HER MOTHER'S DAUGHTER

When the jury reentered, McAleer's questioning took a different tack, but he was still able to elicit a great deal of information about marital life in the Diamond home.

The couple had met six months before they were married and Harry would be at their home above the Calumet Drug Store almost every night according to Pearl. While at first Nettie tried to rid herself of him, he was so persistent that she finally gave in.

A parade makes its way down Michigan Avenue in Indiana Harbor. *Photo courtesy of the East Chicago Public Library.*

MURDER VICTIM'S DAUGHTER TO GO ON STAND THIS AFTERNOON
—*Lake County Times*, May 29, 1923

Pearl Herskovitz, who is a freshman in the East Chicago High School, has her books with her and spends her spare-time in study so she will not fall behind her class.

The girl is expected to tell of the domestic life of Harry Diamond and her mother. She has already told at the coroner's inquest and before the grand jury how her mother had tried to avoid Diamond when he first started paying her attention. At one time she ordered him out of the house but later she yielded to his wooing and married him.

This morning the girl complained to Attorney McAleer that Diamond was trying to catch her eye. She says he had a hypnotic influence over her mother and was now trying to exercise it on her.

Pearl first became aware of the couple's antagonism toward each other about a year after they married. Her mother would accuse Harry of squandering her money.

"He was always asking about money," Pearl recalled on the stand. "She says, 'What are you doing with this money? You are not working any. You just squandering the money away.'"

But Nettie's admonishments didn't stop Harry, who continued to ask his wife for money "all the time," according to Pearl.

When asked what else they argued about, Pearl testified that her mother told Harry that he was out at all times of the night, and he would not stop it, even when Nettie told him to quit.

McAleer asked the young teenager if her stepfather worked, and Pearl responded no, testifying that her mother had told Harry he should do something, but he would not do anything and was living in luxury.

"When your mother told him he should work, what, if anything, did he say about that?" McAleer asked.

"He would not say anything."

GIRL ON STAND IN MURDER TRIAL: PEARL HERSKOVITZ IS FIRST WITNESS TODAY IN HARRY DIAMOND CASE
—Lake County Times, May 31, 1923

Pearl Herskovitz, 13-year-old daughter of Mrs. Nettie Herskovitz Diamond, was the state's first witness this morning at the resumption of the trial of Harry Diamond for the murder of his wife.

McAleer's questioning almost immediately brought about objections from Harry Diamond's defense team and the jury was sent out of the room as McAleer explained to the court that he was trying to bring out the intimate details of the courtship and married life of Pearl's mother and step-father. He said he wanted to show that Harry had married Nettie for her money and that he had made repeated demands for money while they were married. As McAleer talked, he was angrily interrupted several times by William Conroy, chief of counsel for the defense. During direct examination by McAleer, Conroy would also push forward in his chair and center his attention directly on the witness.

"If you don't keep still I'll throw you down the stairs," McAleer finally responded. Conroy objected to his threat and McAleer withdrew it. But Conroy wasn't done with his needling.

"Do you withdraw it?" he asked McAleer.

"You're crazy," McAleer shot back.

Jumping to his feet, Conroy demanded the court to admonish McAleer, who quickly—and heatedly—responded, saying, "I also want defendant's counsel admonished for attempting to place a lie in the mouth of the witness."

"What did she say to him about running around, going out?" asked McAleer.

"She said, 'Harry, what are you doing all day? You don't work any. You are running around with the car. You are running around with other women.

Turning the corner, the horse-drawn parade wagons have to make way for the trolley cars. *Photo courtesy of the East Chicago Public Library.*

Harry, the only thing you can do is to run around with other women. If you will not stop it, I don't need you. I got along without you before I was married and I can get along without after.' He said he would go, 'if you will give me ten thousand dollars.'"

There were girl troubles, too. Pearl testified that her stepfather was friendly with their twenty-one-year-old maid, whom she described as good looking but "of the flapper type." When Nettie learned that Harry gave the young woman forty dollars to buy a dress—a charge that Harry, of course, denied—Nettie fired her.

"He used to give me a check book and tell me to go up to mother's room and have her write a check for him," Pearl testified. "If the check was not as large as he wanted, he would become angry and when he saw mother, he would tear it up and throw it in her face."

Shortly before the murder, Nettie gave Diamond a check for $17,000, which he deposited in his own name, causing a quarrel that had not subsided by the time of the murder.

Then there were the times when Harry asked Pearl's mother for money, and when Nettie asked what it was for, "he'd refused to answer and he'd get sore."

But there were more problems than just a pretty maid and torn-up checks.

Except for Pearl, Diamond didn't get along with Nettie and Sam's children. Originally Nettie had written a will leaving all her estate and guardianship of the kids to Harry but wisely changed her mind. With good reason, according to Pearl's testimony: Harry wasn't nice to his stepsons. He complained when Nettie bought them clothes. He had remarked that the living room of the house was too good for the children and that the basement was good enough, so he attempted to keep them in the basement so they didn't bother him when he was at home.

Harry's intentions toward Pearl were somewhat murkier and definitely had creepy undertones. When she and Anna Cohen Fishman went to visit Harry at the Crown Point jail, Anna tried to get him to tell her where the missing property was.

"Harry, Mrs. Diamond has a lot of bonds which she bought while she was running the drugstore and we can't find them," Fishman said.

Harry boasted that he knew where the money was and that when he got out he'd find it and give it to Pearl.

A float belonging to the First National Bank. *Photo courtesy of the East Chicago Public Library.*

"Did you kiss him at Crown Point?" McAleer asked Pearl when she was re-called by the state and testified in rebuttal.

"Absolutely not," she responded.

"Did he try to kiss you?"

"Yes sir," she said. "Yes, he tried to kiss me and I pulled myself away. I pulled myself away and wiped my mouth with my handkerchief."

Diamond also claimed that he'd given Pearl a diamond ring, and Harry's attorneys called to the stand a jeweler, who said he had sold the ring Pearl was wearing to Harry. Why they wanted the jury to believe that Pearl's stepfather had brought her an expensive ring isn't really clear. Maybe it was to bolster his claims that he loved his stepchildren. Or maybe he saw it as a pledge. But Pearl was having none of that. Her attitude toward Harry in court was contemptuous, saying that her mother had given her the ring. Then Pearl added, in a sharp tone, "Where would he get it?"

Reading the transcripts and the newspaper accounts almost one hundred years later, what comes across is Pearl's remarkable composure under what must have been absolutely horrifying conditions. And it wasn't her first brush with tragedy either. Pearl was around seven when her father died, leaving her mother with four young children—Cecil was younger than two, Bernard had just turned three a few months before and Lloyd was five. She was thirteen when her mother was murdered by her stepfather. She had sat beside her mother's deathbed at Mercy Hospital, listening as she changed her will and gave her dying statement to the police. She had dealt with Harry's father and sister stealing her parents' possessions, and she had to testify not only in court but also at the coroner's inquest and for the grand jury, repeating over and over the events leading to the death of her last living parent. Now, she and her brothers were orphans.

Despite all these travails, there was never any indication from the many reporters covering the crime or from witness testimony that Pearl ever faltered or weakened. She had the steel and determination of her father, who had risen from poverty in a remote Balkan country, just one of many siblings belonging to a widowed mother, to become a well-respected and civic-minded doctor in Indiana Harbor in less than sixteen years.

Nettie's mettle, too, was remarkable. She seems to have been able to extricate herself from an early marriage or relationship that resulted in the birth of a disabled son, completed pharmacy school at a time when few women even went to college, married a successful and handsome pharmacist and doctor from a good family, had another son by him and then divorced him to marry Sam, with whom she had four more children during their

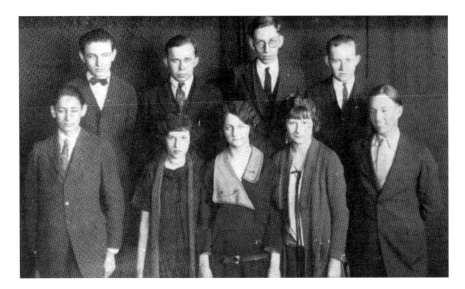

Above: Pearl, second from the left on the bottom row, also was on a co-ed debate team at Washington High School in Indiana Harbor. Worried that she wasn't keeping up with her studies while attending the trial of her stepfather, Pearl Herskovitz was a super-achiever. *Photo courtesy of the Lake County Public Library.*

Right: Nettie and Sam's children excelled in school and were involved in many extracurricular activities. In this yearbook photo, Pearl is shown in the middle photo at the top of the page, and her brother Lloyd is on the right at the bottom of the page. *Photo courtesy of the Lake County Public Library.*

11
IN HIS OWN WORDS

Did you try to have a spell in the drugstore?" McAleer asked.

"I did not try, I had a bad spell," Diamond retorted.

McAleer said, "Diamond, you are not telling the truth."

The accused man leaped from his chair.

"I am, I am," he shouted. "I have bred my life to tell the truth."

Diamond spoke of his dead wife in low tremulous tones and said that he had never harmed her in his life. He reiterated his love for her, which he said he knew was reciprocated.

McAleer asked Diamond if he saw a man in or near the automobile at the time of the shooting. Diamond replied that he saw a man's shadow. McAleer explained that the sun was not shining that day and that the weather was dismal, to which Diamond replied that he wasn't sure whether what he saw was a shadow or a form.

Next the state's attorney asked about the insurance applications that had been taken out by Diamond and his wife, on which he omitted his epilepsy. Diamond admitted to lying to the insurance company.

"Did your wife accuse you of shooting her?" asked McAleer.

"Yes," replied Diamond. "She blamed me in the car and also in the drugstore. She did this because she was jealous of me."

Under questioning by his attorney, Diamond claimed he had bought the Hudson, the one they were riding in, on Valentine's Day for his wife and denied that he had "at any time, with a revolver or gun," shot his wife.

"Did you ever beat her over the head?" Conroy asked his client.

NETTIE AND I WERE JUST A PAIR OF KIDS: DIAMOND TELLS THE
JURY THAT HIS WIFE AND HE WERE SWEETHEARTS
HAD FIT AND LOST HIS SENSES: MANY OF JURORS WOULDN'T
LOOK AT DEFENDANT AS HE TESTIFIED
—*Lake County Times*, Tuesday, June 5, 1923

Diamond suffered a severe grilling under W.J. McAleer and has shown more worry than has been visible since his arrest. Diamond admitted under cross-examination that he had raised checks (written checks without having the right amount of funds in the bank to cover them) and expressed his belief that check raising was no crime.

The accused leaped forward from his chair this morning on two occasions, once when McAleer asked him if he tried to have an epileptic spell in the drug store to which he had taken his dying wife and again when the state's representative accused him of lying.

"No, sir."

"How did you get along?"

"We were like a couple of kids. We were sweethearts."

"How old was Mrs. Diamond when you got married?"

"Twenty-nine."

"How old were you?"

"Twenty-one."

Harry then testified that he treated his stepchildren as though they were his own. And they, in turn, treated him with respect. He also denied that he had ever told Nettie's children to stay in the basement when he was home.

If Harry thought his lies and charms would save him, the attitude of the jury should have shown him that wasn't so.

Opposite: Indiana Harbor was a tough town, full of people who had come to work hard, make money and take advantages unavailable in their homelands. It was a city of churches but also of bars, gambling dens and other places to have fun, such as shown in this 1910 photo of Palmer's Billiard Parlor. *Photo courtesy of the East Chicago Public Library.*

THE FIGHT FOR HARRY'S FATE

These enemies of Harry Diamond have given hear-say evidence that would convict Christ himself," said defense attorney Joseph Conroy in his closing argument, according to the *Times* on Thursday, June 7, 1923.

CLOSING SPEECHES IN THE DIAMOND MURDER CASE
—*Hammond Times*, Wednesday, June 6, 1923

The closing argument of William McAleer, special prosecutor, will be remembered in Valparaiso for many years. It was the most vigorous and compelling indictment of a criminal ever given in a courtroom in Indiana attorneys agreed.

NEVER ACCUSED BEFORE

In opening his argument, Attorney McAleer replied to the charges of Attorney William A. Mathews for the defense that the state's evidence had been framed.

"I have practiced law for over a quarter percent of a century," says McAleer, "and never before was I accused of trying to fix testimony. That charge comes from a carpet bagger lawyer with a dirty collar."

The major newspaper was the *Hammond Times*, a daily still in existence but now known as the *Northwest Indiana Times*. The *Times* had several "local" editions, including one for Indiana Harbor. The *Gary Tribune* was a big competitor, though it's hard to tell from this photo. *Photo courtesy of the Calumet Regional Archives, Indiana University.*

Now Conroy started with one of his usual 4th of July speeches. Then he called the colored boy a liar. He said that little Pearl Herskovitz testified that the colored boy drove her home from the Diamond house

Sunday night before the murder when he said in his testimony that he was in Hammond with Diamond and the other woman. Pearl did not testify to any such thing. I say he lied but maybe he didn't mean to do it.

We are asking you to inflict the death penalty upon a self-confessed bootlegger, check kiter and perjurer who has committed the most dastardly murder that was perpetrated on this earth. He is a contemptible character, a man who admits that he made from $100 to $500 on eight women in the notorious resort he operated in Gary. Where did he [get] the diamonds he sold? He got them from sneak thieves and holdup thugs.

Here is a bootlegger and a man who kept women for hire marrying a woman who has four children and who is 16 years his senior. Did he love that woman? No he didn't. He loved the money.

McAleer pointed at Diamond. "He hated her," he shouted, "and he killed her!"

"You lie!" cried Diamond, half rising from his chair and glaring at the prosecuting attorney.

"Look at him," said McAleer to the jury. "Just look at his vicious face. If he had a gun he'd kill me."

CAN YOU BELIEVE HIM

"Can you for one minute believe a single word he said?" continued McAleer.

He wants you to believe him against the dying declaration of his poor wife and the testimony of the colored boy. He says that police lie when they say he told them this gun, splattered with the blood of his dying wife, belonged to him.

He can tell you what became of the money and the diamonds. How easy for him to plant them after the crime and send one of his sisters to get them. How easy it would have been for him to tear up the ante-nuptial agreement if he had been successful in killing his wife and the colored boy.

Now Diamond says he saw Armstrong signal to two Negros in a Ford. Joe Conroy don't believe that story himself. I know who made it up. Mathews did. Where is Matthews?

Attorney Matthews had left the courtroom, McAleer was told.

MADE UP STORY

Well, anyway, Matthews made up that story.

Diamond carried his dying wife into the drugstore and threw her on the floor. He thought she was dead but she came to and there in the presence of Stover, the drug clerk, she accused her husband of killing her and he replied, "I know I did, but I didn't mean to do it."

Conroy says the dying declarations are not evidence but the court has said they are and Conroy knows it.

REFERS TO LETTER

"What about this letter that was found on the road near the scene of the crime?" continued McAleer. Turning to Diamond, he said:

It is stained with the blood of your wife from your own fingers, Harry.

The colored boy told the truth. Diamond dictated that letter. It came from the shrewd crooked brain of Diamond, a brain that had been running in criminal channels for years. Would the colored boy write to his parents that he was leaving town with an automobile and diamonds and several thousand dollars? Wouldn't they know he was a killer if he did?

Diamond tried to place that letter in the colored boy's coat, and it dropped out as the little fellow ran for his life. Didn't Diamond ask the police if they found anything on Armstrong?

HER PLEA TO BRUTE

Remember her pitiful pleas to this human brute. "Oh Harry, you shot me and shot me and shot me and you pounded me over the head and pounded me over the head. Why did you do it? How could you separate me from our seven-months-old babe?"

Remember that and then KILL HIM!

She wanted to take him to heaven so she accused him of killing her so that he would go to the electric chair! Do you believe that story? Could

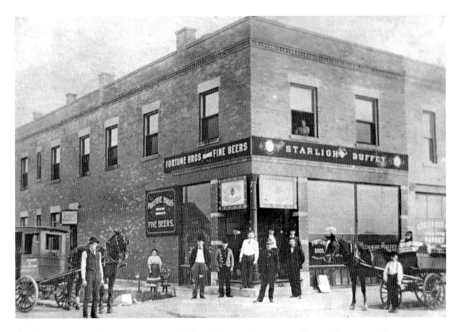

A place for a workingman to get a drink and something to eat. It wasn't unusual for men to spend more of their paychecks than they should have on payday, a fact that their wives didn't like at all. *Photo courtesy of the East Chicago Public Library.*

any man believe it? If he had been innocent of killing her would she have wanted to take away the father of her little babe and rob it of its only protection?

If he had been innocent, she would have said in her dying statement, "Harry take care of the children for me."

Then there is the hired girl episode. They never denied that. It must have been true.

There was never in your life a time when responsibility rested so heavily on you. You are sworn to do your duty and uphold the law. It is a disagreeable duty, but my God, men, what else can we do with this creature except kill him. My heart goes out to his poor old mother, but she'll be better off without a son like him. I say that the good people of Indiana are watching to see if we're going to do our duty.

For the sake of decency and law and in the name of womanhood, stand by your guns and kill him. Society demands that he go to the electric chair and suffer death.

A Jazz Age Murder in Northwest Indiana

Frank Parks Opens for the Defense

Parks had been dubbed by his friends "Honest Abe" because he had defended so many Negros charged with murder and brought to Valparaiso on a change of venue. Some got free, and none paid the death penalty.

The overflow crowd in the corridors could hear Parks. He spoke loudly. He was working on the emotions and sympathies of the jury.

Speaking in defense of Harry Diamond, Attorney Parks said:

> *You, gentlemen of the jury, have been selected to try a man for the murder of his wife, and your task is great. I don't know who has committed this murder.*
>
> *History shows that some of the Lake County officials go to Indianapolis to obtain forgiveness for their sins while others not so fortunate go to Atlanta, Georgia, where there is a federal prison. With that in mind you may believe in that this charge is a frame-up to railroad Harry Diamond to the electric chair.*

Parks then described Diamond's conduct throughout the entire affair as above reproach. He said that Diamond came out of a stupor in which he was lying at the bottom of the auto, sprang to action, wrestled a revolver from the assassin William Armstrong and shot him.

> *Diamond did everything he could for his poor dying wife. He took her to a drugstore, called doctors and police, which is more than any other living man did. There were eight men in the store, and not one did a thing.*
>
> *Then Diamond collapsed. There is not a man on the jury who would not have collapsed under such an ordeal. Just think, gentlemen, to have your wife murdered before your eyes and be helpless to prevent it; to have an encounter with a Negro and then have your wife tell you on the way to help that she blamed you for the murder. Is it any wonder that Diamond collapsed?*
>
> *Did the police and the people in the drugstore go out to the scene of the murder? No. They went to see the colored boy in the hospital. Why didn't they take him to the police station? He might tell the truth, so they took him away to sign his story.*
>
> *Diamond has done all he could in this trial. He has sat in the witness box and told the truth. He has a little child to raise and a poor old mother to care for. She is praying to God that you will spare her boy.*

The school population in Gary exploded with the advent of workers and their families arriving to work in the mills. Portable schools, which were attended by Nettie's children, were put in place while new schools could be built. It was at one of these that William Armstrong dropped off lunch before taking Harry and Nettie on that fateful trip. *Photo courtesy of the Calumet Regional Archives, Indiana University.*

At this point, Mrs. Diamond and her daughter wept. Harry Diamond dabbed a handkerchief to his eyes.

"It is a horrible affair," Parks continued.

> *Harry Diamond regrets it more than any of you do. I would like to reveal to you the great mystery surrounding this murder, but I can't.*
>
> *Diamond has told the truth, and no man's liberty is safe when you cannot believe him under oath if his story is not contradicted. Men who sometimes violate the law are often proved to be the best to their families. Such is Harry Diamond.*

Next Matthews reiterated that the evidence of the state was "framed," and Conroy declared that William Armstrong, the chauffeur, had been proven a liar. In a description of the terrible death Diamond would suffer if sent to the electric chair, Conroy became very dramatic, and Harry's mother swooned and had to be revived by smelling salts by her daughter.

During his argument, Conroy turned on Mrs. Ann Cohen Fishman, lifelong friend of the slain woman, who was not a witness in the case

but sat at the side of Pearl Herskovitz, the orphaned daughter of Mrs. Diamond.

He charged that she had influenced the testimony of the girl because of her hatred of Diamond. McAleer interrupted, telling the court that the argument was unfair and that Mrs. Fishman was a kind woman and like a mother to the girl.

"These enemies of Harry Diamond have given hear-say evidence that could convict Christ himself," said Conroy.

In reference to Diamond's mother, Conroy wept.

The End of the Trial

Everyone is hot and tired. The court room has been crowded and the day is sultry. The attorneys present the court with copies of instructions, one set prepared by the state and the other by the defense. From these instructions the court will select some points and incorporate them in the instructions which he will read to the jury.

W.J. McAleer, attorney for the state, and Joseph Conroy, attorney for the defense, are talking to each other, but they do not appear to be very friendly.

Diamond is talking to his father, a little man with dark circles under his eyes and a worried countenance. Diamond's sisters are

The executives of the steel mills lived in mansions surrounding Washington Park in Indiana Harbor, a place with greenhouses, a zoo, a public swimming pool, a playground and tennis courts. *Photo courtesy of the East Chicago Public Library.*

standing near. The father and one of the sisters were indicted by a grand jury at Crown Point for stealing the slain woman's clothes from her home, but they are not worrying about that now. They are worrying about Harry.

Mrs. Diamond has her handkerchief to her eyes. She is hardly able to walk and leans heavily on the shoulder of one of her daughters as she leaves the court room. She has heart trouble and may not live long.

Down in the court house square men are gathered in groups asking each other the question. In the barbershop on the main street a customer is telling the barber the last developments of the trial. Down at the Elks' Club, members gather around the bar to drink near beer and speculate on the verdict.

It is zero hour for Harry Diamond.

Only Two Ballots

The jury retired to its room at four o'clock. On the first ballot stood twelve for conviction; ten for death and two for life imprisonment. The jury then went out to supper and, after returning, cast the second and last ballot. It was twelve for conviction and twelve for death. Judge Loring was notified, and the courthouse bell rang to signal to the town that the jury was about to return a verdict.

Diamond Will Die
Thursday, June 7, 1923, *Times*
By Harold Cross

Valparaiso, Ind.
The "shadow" that Harry Diamond saw as his wife lay dying in the Hudson sedan on the road to East Chicago, the cold dismal day in February, and the colored boy with a bullet in his head ran screaming down the road, was not the form of an unknown assassin and robber.

It was the shadow of the electric chair in Michigan City.

The unknown assassin did not kill Mrs. Nettie Herskovitz Diamond and shoot the colored boy. Diamond did it himself. The Porter County jury so decided last night and returned a verdict of death.

The verdict was read by Judge H.H. Loring at 8:30 o'clock, four hours after the jury had begun its deliberations.

The courtroom was jammed with spectators. Only the defendant's mother and sisters and the attorneys for the state had gone home.

Diamond's father, a little man, sat with his head in his hands, swinging from side to side. Diamond sat between his attorneys nervously locking and unlocking his fingers. His skin was yellow.

Amos Richmond, a farmer, stepped from the jury box after the jurors had been brought into the room. He had been selected foreman. He handed Judge Loring a paper folded in the center.

Not a person in the throng moved. It was still—the stillness of death.

THE FIRST DEATH VERDICT

Judge Loring began to read. He appeared to be under a great strain. It was the first time he had ever read a death verdict. Not since 1837 had there been a penalty of death inflicted in Porter County.

"We the jury," he began, "find the defendant Harry Diamond guilty of murder in the first degree as charged in the indictment and fix the penalty as death."

Death!

Harry Diamond turned deadly white. His head fell forward. He began to whimper and whined like a little boy. His father was crying and came toward him. The father fell on the boy, his arms around him and sank to the floor. They held each other in a tight embrace, both crying.

PRISONER IS HANDCUFFED

"Oh, Father, this is terrible this is terrible," whimpered the doomed man.

The little old man could not speak. He is not more than 5 feet 3 inches tall and he wears trousers that bag at the knees and a coat far too large. His head is bald and he looks tragic.

The court discharged the jury. The stillness of the crowd broke and in its place there was the scuffling of feet and roar of conversation of hundreds of people. Judge Loring rapped for order. The sheriff and his deputies walked to Diamond and laid their hands on his arms. He arose uncertainly.

The handcuffs clinked on his wrists and he walked bareheaded and with unseeing eyes from the courtroom down the stairs and across the street to the jail. He seemed not to hear the questions or reporters.

"Turn on the Light"

It was dark in the big cell room. There were no other prisoners. The deputy sheriff snapped the iron gate shut behind the condemned man. Diamond stood with his hands gripping the bars.

"My God, Bill," he said to the deputy sheriff in a broken voice. "My God, turn on the light. Don't leave me in the dark."

The sheriff switched on the light. Diamond sank to his knees beside the cot and buried his face in his hands. He was motionless as the sheriff left for the night."

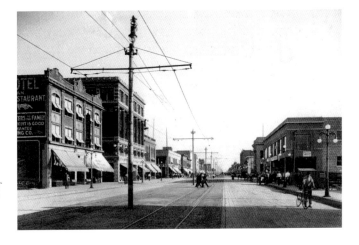

Downtown Gary around the time that Nettie and Harry lived in the city. *Photo courtesy of the Calumet Regional Archives, Indiana University.*

BULLETIN
—Lake County Times, June 7, 1923

Valparaiso, Indiana.

Mrs. Esther Diamond, the mother of the condemned man, came to the courthouse this morning and stayed in corridor for several hours weeping. She fainted and was cared for by her daughter. Court attaches were deeply moved by the scene enacted by the grief-stricken mother. She went to the jail to see her son. This afternoon Judge H.H. Loring will render judgment on the verdict. The state appears confident that the motion for a new trial will be over ruled. Judge Loring expected to pronounce sentence upon Diamond this afternoon, fixing the date of his execution. The defense will appeal to the Supreme Court of the state if the motion for new trial is denied.

EXTRA! OCTOBER 12 DATE FOR
DIAMOND'S EXECUTION
—Vidette Messenger, Thursday June 7, 1923

At 2:30 this afternoon and heavy [*sic*] Harry Diamond was brought into court by Sheriff Pennington and Deputy Forney to receive the date of his execution. Judge Loring asked the defendant to stand up, read him the verdict of the jury finding him guilty of murder in the first degree and imposing the death penalty. The judge asked him if he had anything to say why sentence should not be passed, and in a clear and calm voice answered, "I have nothing to say Your Honor."

The judge then told him that in accordance with the verdict of the jury he ordered his execution to take place before sunrise October 12, 1923 "by the passing of electricity through his body."

DIAMOND IS TO DIE ON OCTOBER 12 CONDEMNED MAN APPEARS WEAK AND DEJECTED HE SAYS NOTHING
—Lake County Times, Friday, June 8, 1923

SIX MEN GUARD DIAMOND

Diamond was brought into the courtroom in handcuffs and surrounded on each side by a deputy sheriff. A prison guard walked in front of him, and in the rear was another guard as well as two policemen. The handcuffs were removed as he stood before the judge's bench, and he was described as being pale with large circles beneath the eyes. Reporters thought he appeared dejected and weak but still composed. Diamond's father and mother were sent out of the courtroom as the sentence was being passed. They stood in the hall, and when Attorney McAleer passed out of the room, Mrs. Diamond made a plea for her boy: "Don't kill my boy, don't kill Harry."

"I am very sorry for you, Mrs. Diamond," said McAleer. "But Harry killed his wife, and he didn't give her a decent killing either. He beat her to death while she pleaded for her life. He made those four little children orphans; he killed the mother of his own baby. I conducted this case fairly, Mrs. Diamond, and I am sorry for you."

Mrs. Diamond turned away without saying anything. She went to her husband, who was sitting in a chair in the anteroom. The little old man presented a picture that wrung the hearts of spectators.

Attorney Conroy was talking to Jerome Bartholomew, one of the jurors and an old friend.

"You made a good fight, Conroy," said Bartholomew. "But there wasn't a chance for him. He killed her and deserved to die for it. We stood ten for death and two for life imprisonment on the first ballot and the other two swung over. It wasn't a question of guilt or innocence but just a matter of death or life. We knew he was guilty."

Attorney Conroy announced that Diamond and his family had exhausted their resources. He said Diamond was convicted because of prejudice. It was rumored that there were three members of the Ku Klux Klan on the jury, but the source or truth of the rumors could not be ascertained. There was one Catholic.

Attorney McAleer pointed out that the death penalty had not been inflicted since 1837 in Porter County and that several Negros, tried for murder, had been freed within the past few months, indicating that Porter

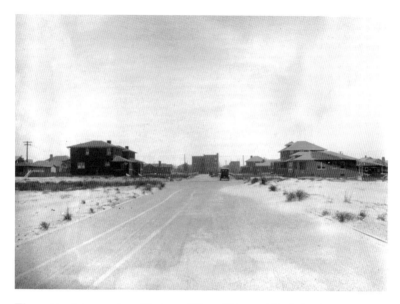

The residential area where Nettie and Harry Diamond lived shortly after their marriage until her death. The solid-brick, two-story home still stands today. *Photo courtesy of the Calumet Regional Archives, Indiana University.*

County juries were not prejudiced. He said he studied the jury during the trial and never saw twelve men more earnestly seeking to be fair and impartial.

Another member of the jury stated that the prosecution riddled every witness for the defense and left the jury nothing to do but convict.

"The defense did all that it could, but it didn't have a leg to stand on," he said. "Conroy said that if the friends of the Diamonds came to their aid financially, the case would be appealed to the Supreme Court."

WINS DEATH PENALTY IN PORTER COUNTY
—Hammond Times, June 11, 1923

Not since 1837 had the death penalty been inflicted by a jury in Porter County until W.J. McAleer of Hammond, acting as special prosecutor for Lake County, prevailed upon a jury last week to send Harry Diamond to the electric chair for the murder of Nettie Herskovitz Diamond, his wife.

The prosecution of Diamond was McAleer's greatest achievement as an attorney, it is declared by his friends. The evidence was well presented and the closing argument was rigorous and compelling. Attorney McAleer also holds a record in personal injury suits, having obtained a judgment of $35,000 for the loss of a leg in the Herbert Melville case.

DIAMOND THROWS OFF BLUES, AND HOPES FOR LIFE:
CONDEMNED MAN RECOVERS CONFIDENCE
THAT HE WILL ESCAPE CHAIR
—*Hammond Times*, June 11, 1923

Harry Diamond, convicted of the murder of his wife, and condemned to die in the electric chair, October 12, appeared to have recovered his spirits. A local barber, called to the jail to cut Diamond's hair, took with him a pair of clippers that operate by electricity. The barber was not tall enough to connect the extension of the clippers with the electric light socket and he asked Diamond, who is rather tall, to do it for him.

"Where do you get that stuff," said Diamond. "Do you think I want to get electrocuted?"

Diamond hopes now that the sentence will be commuted to life in prison.

DIAMOND'S MOTHER APPEARS IN COURT:
MAKES FRANTIC APPEAL TO JUDGE LORING TO
GIVE HER BOY A NEW TRIAL

Carrying Fay, seven-month old the daughter of Harry and Nettie, in her arms, Mrs. Esther Diamond appeared before Judge Loring in circuit court yesterday and made a frantic appeal to the jurist to "give my boy a new trial."

Pearl, second from the left on the bottom row, was a member of UXI Club, the first female debate club at East Chicago Washington High School in Indiana Harbor, which she attended when she was living with Anna Cohen Fishman. The copy under this photo reads, "The girls intend to challenge the boys to a debate before the semester is ended. Go to it girls. Stick to your reputation of knowing how to argue." *Photo courtesy of the Lake County Public Library.*

When told that a new trial was a matter of law and cannot be given promiscuously, Mrs. Diamond left the court room, weeping feverishly.

"It's terrible, it's terrible," she told her husband who was waiting news of her appeal in an outer room.

"They can't," she kept repeating as Harry's father urged her outside.

"I can't see what we are going to do," Harry's father wailed. "We have no money and someone said it would cost three hundred dollars or so to appeal the case. What can we do? I have done everything I can and now I have to go back over to jail and tell Harry that the law must take its course and that a new trial will come only if there is a legal reason. He will take it hard, I know. My poor boy."

Harry's father also worried about his son's weakened condition. "Although Harry does not give way to tears," he said. "I can see that he is greatly worried and is weakening. It's a terrible thing but I do not see what we can do."

DIAMOND'S LAWYERS FILE BILL
—*Lake County Times*, Monday, June 18, 1923

A bill of exceptions to the court's instructions in the case of Harry Diamond, sentenced to die electric chair October 12, was filed Friday in the Porter Circuit Court. Preparations are being made by the court reporter to complete a transcript of the evidence showing the exceptions which the defense expects to use in support of a motion for a new trial. This motion will be filed about July 1, it was said. Judge H.H. Loring has ordered the clerk of the court to set the arguments on the motion for the first Tuesday of the September term.

SEE ATTEMPT AT DIAMOND JAIL ESCAPE
—*Times*, Wednesday, June 20, 1923

An attempt was made at a jail delivery in Porter County last Monday night, but the effort failed because of the extra precautions taken by Sheriff Pennington to prevent anything of this kind. Who made the attempt is not known, but it is believed that Harry Diamond, under death penalty, is the only one who made the break for liberty.

One bar, on an outside window of the jail, had been sawed completely off by a prisoner. No saw was to be found and none of the prisoners knew anything about the matter. A careful search by Mr. Pennington located the saw hidden in a sewer trap. The sheriff is at a complete loss to know how the saw got

inside the jail. He is very careful about admitting any visitors and is to be commended on his promptness in preventing it from being accomplished.

Mr. Pennington stated that he would be greatly relieved when he could transfer Harry Diamond to the Michigan State Prison to await the date for his execution.

Judge Loring yesterday denied motion for a new trial after Attorneys W.J. McAleer and Joseph H. Conroy, for the state and defense respectively, had argued for five hours. In denying the motion the court said there had never been a case tried before him so free of error.

Diamond was brought to court from the penitentiary at Michigan City by two armed guards. He wore the gray stripes of prison garb and appeared disconsolate. He has lost weight and his face is thin and wan. The only trace of spirit was the angry glances at Attorney McAleer. One of the dramatic incidents of the trial last spring was when Diamond jumped to his feet and shouted at McAleer, "You lie," and the attorney said to the jury, "Look at him! If he had a gun now he'd kill me."

Take Diamond to Michigan City for Execution
—Lake County Times, Thursday, June 21, 1923

Bulletin (International News Service): Harry Diamond, convicted Gary wife slayer, was taken to Michigan City today under heavy guard, Porter County officials fearing another attempt at jail breaking. Attorneys for Diamond announce that every legal effort would be made to save him from death in the chair.

Attorney W.J. McAleer petitioned the circuit court for an order for the immediate removal of the convicted man to the state penitentiary at Michigan City to await execution October 12 in the electric chair.

The action of the prosecutor followed an attempt of Diamond to break jail. He had sawed through one bar at the window of his cell and the saw was discovered hidden in the sewer trap. The prison was waiting until night to finish the job and escape.

"If Harry Diamond gets out of jail he will be the most desperate man ever at large in Indiana," said McAleer. "He would kill at sight."

Did Diamond Try to Kill Himself?
—Lake County Times, June 23, 1923

What is believed to have been an unsuccessful effort on the part of Harry Diamond under sentence of death for the murder of his wife, to end his life, is said to have been made in the cell room of the Porter County jail shortly before the prisoner was removed to the state penitentiary at Michigan City.

According to a report, believed to be authentic, Diamond walked to the rear of the cell room and placed a bottle to his lips. He turned pale almost immediately, and his condition appeared to have become greatly weakened. Considerable credence to the report that he had taken poison was given when he became very ill during the trip to the prison.

Diamond Is Refused New Trial:
Date of Execution Postponed However by
Granting of Appeal to Supreme Court
—Times, Tuesday, September 18, 1923

Harry Diamond will not die in the electric chair, October 14. The date of his execution has been indefinitely postponed by the granting of an appeal to the Supreme Court of the state. It is probable that

the Supreme Court will not review the case before six or eight months and [in] the event that the verdict is sustained Diamond will go to the electric chair sometime next fall.

If the Supreme Court says that Diamond shall die the only intervention that will save him will be a commutation of his sentence by the governor. There is no appeal from the Supreme Court of the state in a murder case. In reviewing the case, it will consider only whether Diamond was given a fair trial and if there appear to be any fatal errors he will be granted a new trial.

13

HARRY'S LAST DAYS

Governor Says Diamond Must Die:
Murderer's End Comes Tomorrow Morning:
Remarkable Efforts Made to Save Life of
Wife Slayer by Attorneys
—*Lake County Times*, Thursday, November 13, 1924
Written by Harold Cross

Harry Diamond, Gary, Indiana wife murderer, sat in the death cell of the Indiana State prison here today, counting the minutes until eternity. He will die sometime between midnight tonight and daybreak tomorrow. No one except prison officials will witness the execution.

Last Hope Gone

This time, there is no reprieve. Governor Emmett F. Branch, on whose leniency Diamond placed his last desperate hope, refused yesterday to commute the sentence to life imprisonment. It had thus been advised by the state board of pardons, before which attorneys lost an eleventh-hour battle to save Diamond's life. They argued he had become insane since his

The Hebrew translation on Nettie Diamond's tombstone is "Nacha Devorah Daughter of Yaushua." Nettie Dora Diamond is buried in our Progressive Order of the West Section, Gate 37, Lot 2202, Row 2. *Photo courtesy of Waldheim Cemetery Company.*

incarceration, a condition that precluded capital punishment. It is understood that scores of telegrams went to the governor from Lake County asking mercy, but the executive stood firm.

"The man had a fair trial by a court and a jury, was sane then, had been sane ever since and the governor can find no legal grounds for commuting the sentence so I refused the plea," the chief executive said.

Governor Unrelenting

Governor Branch arrived and the father and mother were admitted to his office. They pleaded that the death sentence be commuted to life imprisonment. The governor refused then they asked for a stay of execution to permit a further investigation of Harry's mental condition. Governor Branch stated that the courts had decided Harry was sane. He could do nothing.

The chance in a thousand was gone, continued Cross, the only reporter whose byline appears in the countless news articles and who could always be counted on to write a gripping, dramatic story. The message was sent to Fannie Diamond, Harry's sister, at Gary, and accompanied by her younger brother, she left for Michigan City, where she was admitted to the prison. Clinging to

the bars of his cell and sobbing pitifully, she told Harry that the governor would not grant a stay of execution and there was no hope for a reprieve.

Harry patted her hand. "It's cut and dried, sis, and I'll take my medicine. I'm not afraid of the electric chair."

"What can I do Harry?" Fannie asked.

"Take the kid and go back to Gary and don't let the folks come here. I don't want any of you to be here when it happens. Tell Mother and Dad I love them, and tell Mother I am sorry I brought this disgrace upon her. I'd like to see Rabbi Hyman."

"He'll be here, I know," said Fannie.

Nothing more was said, although Fannie and the boy lingered for several minutes. They kissed Harry through the bars of the cell and left.

The inscription on Sam's tombstone reads, "In Memory of My Beloved Husband, Our Father, Dr. Samuel Herskovitz, Born February 2, 1884, Died March 29, 1916: Gone but Not Forgotten." *Photo courtesy of Waldheim Cemetery Company.*

Harry Diamond had always had the greatest respect for Rabbi Hyman of Gary, and it was natural that he should turn to him in the last hours of his life. He was the rabbi of the synagogue Harry had attended as a boy. Diamond told the guard he wanted Rabbi Hyman to perform the last rites of the Jewish religion, which is the confessional.

Harry waited for the rabbi and then finally lay down on his cot and went to sleep.

At five minutes to twelve o'clock, the door to Harry's cell opened, and two guards walked in. In the corridor stood the ward, the chaplain, the physician, Dr. F.H. Weeks and a practicing physician of Michigan City, Dr. J.J. Kerrigan.

Cross appears to have had deep connections in the Michigan City prison; he even could have been an observer to Harry's last moments. He

Photo of Samuel from his tombstone. It has weathered the years well. Interestingly, he and Nettie don't rest together. He is buried in our Independent Order B'rith Abraham Section, Gate 53, Lot 1159, Row 59, Grave 3. *Photo courtesy of Waldheim Cemetery Company.*

reported that in the evening, Diamond ate his usual prison fare.

"Well, I guess I'll get my first electrical treatment tonight," Harry said to the prison guard, laughing. There was no mirth in the laugh.

For a time, Harry whistled to keep up his spirits. It was a frivolous song.

HE DISPLAYS EMOTION

Diamond got up unaided and straightened his coat collar and tie. He looked at the men standing in the corridor and said "Where is Rabbi Hyman?"

"He didn't come," replied Fogarty.

"God!" ejaculated Diamond. It was his only display of emotion.

"Are you ready?" questioned Fogarty.

"Must I go now?"

"Yes."

Diamond picked up the comb which hung from a chain on the wall of his cell and parted his hair carefully. He brushed the well-fitting blue suit.

"I am ready," he said, stepping out of the cell.

He walked to the execution chamber unaided. He entered smiling. It was not a pleasant smile. It was a smile more tragic, more ghastly and more horrible than the most anguished writhing.

It Was Too Late

In the lobby of the prison, Rabbi Hyman was excitedly begging the guard for admittance. He had not been notified until late because he had been away from home. He must see Harry before the execution. It was impossible, the guard told him. Diamond was being led to the execution room and it would be over in a minute.

The little Rabbi's eyes were wet with tears, but he was not without spirit.

"Can't a man make peace with his God before they kill him in Indiana?" he demanded.

Chaplain Offers Prayers

Harry Diamond gazed at the electric chair a moment.

As he sat down, he pulled the legs of his trousers a trifle as though to keep the knees in crease. Undoubtedly he was unconscious of the act. The chaplain offered a prayer to God for the soul of Harry Diamond.

"Have you anything to say?" asked Warden Fogarty.

Diamond shook his head. The smile was blanched. He was resigned and beaten. The braggadocios of the trial and of long weeks in prison had been broken. He sat in the electric chair as helpless as a baby. He seemed unable to so much as raise his hand as the black cap was adjusted.

Perhaps through the mind of Harry Diamond there flashed the picture of the mad passion in the automobile on the road to East Chicago February 14 when he shot and beat his wife and shot William Armstrong, their Negro chauffeur. With all the hate and malice gone it must have seemed like an ugly dream to him as he sat waiting [for] death. Why had he killed her, the woman twice his age?

What Were His Thoughts?

Perhaps he thought the things he had meant to tell Rabbi Hyman.

Harry's aged father and mother were back in Gary, hopeless and ill. The trip home from Indianapolis had been tortuous. It was midnight. Their boy was being killed by electricity in the prison at Michigan City that the law might be avenged.

Diamond had been strapped in his chair. There was a pause of barely a second in which the warden, the physicians and the two guards stood motionless looking at the silent figure in the chair. Then at a signal from the warden a guard pressed a button.

Dies Without Confessing

Two thousand three volts of electricity passed through Diamond. His body stained at the strappings and after a brief convulsion, became tense and rigid. There was no burning flesh as the interlocked oil switch method was being used. Then followed a shock of 500 volts and finally another shock of 2300 volts.

The first volt was sent through his body at 12:04 o'clock. He was pronounced dead by the physicians at 12:10. It was exactly 21 months from the day that he killed his wife.

Out in the lobby of the prison, the little man in the cloth of the church was praying on his knees. The room was filled with newspaper men, restless awaiting news of Diamond's death.

At 12:14 Warden Fogarty came through the prison gates and announced that Diamond was dead.

Body Is Claimed

Lewis Berger, Harry's uncle, of Waukegan, Illinois, stepped forward and claimed the body. At that moment it was being placed in an undertaker's wagon.

Rabbi Hyman and Berger trudged through the night to the undertaker's room. The streets were alive with town's people [sic] gossiping about the ninth execution to the credit of the great state of Indiana.

The rabbi and the uncle entered the office of Ott's undertaking establishment and were escorted back to the room in which the body of Harry Diamond, still warm, was laying on a slab.

The uncle went back to the office with the undertaker to make out the papers necessary for shipment of the remains to Chicago for burial.

Rabbi Hyman was alone with the earthly remains of Harry Diamond.

Berger, whose wife is a sister of Diamond's mother, said that the body would be buried in Chicago as the parents of Diamond are contemplating moving from Gary to Chicago in the near future in the hopes of "forgetting what has just happened."

Interestingly, Harry would be buried at Waldheim Cemetery where both Nettie and Sam were laid to rest.

Harry Diamond, 26, had died without confessing and without making his peace with His Maker.

DIAMOND GOES TO HIS DEATH SMILING:
HE MEETS HIS DEATH UNAFRAID: TELLS HIS SISTER
HE'S NOT AFRAID OF THE ELECTRIC CHAIR
—*Lake County Times*, Friday, November 14, 1924

Harry Diamond died smiling unafraid. He met his gruesome fate like a man.

Yesterday morning at 8:00 O'clock Edward J. Fogarty, the warden of the Indiana Penitentiary, went to the death cell to tell Harry Diamond the wife murderer that he must die at midnight.

The good looking young man made no comment. The warden left and Diamond returned to his cot. It was the only one chance left, just a chance in a thousand, he told the warden. Down at the statehouse in Indianapolis, his aged father and mother were seated on a bench in the corridor just outside the door of the governor's office. They were alternately crying and consoling each other.

Gary Police Department. *Photo courtesy of the Calumet Regional Archives, Indiana University.*

HARRY DIAMOND PAYS IN CHAIR FOR SLAYING OF WIFE: ADMITS GUILT EARLY IN THE DAY; GOES TO DEATH CALMLY AND SMILES AS STRAPS ARE ADJUSTED
—*Indianapolis Star*, November 15, 1924

HIS LAST DAY

Warden Fogarty told Diamond in the morning that he was to die in the chair at a few minutes after midnight and listened to the grim words smiling and unflinchingly. He acted the same way throughout the day, appearing [in] the best of humor.

At dinner time he told one of the guards, "Guess I'll take my first electric treatment tonight."

At 3:30 o'clock in the afternoon, Fannie Diamond, sister of the prisoner, and a brother called on Harry who admitted to them that he committed the deed for which [he] was to suffer the extreme penalty. Following his confession, he deplored the crime,

saying that he was suffering an epileptic fit when it happened. "Since no jury in the world would believe me, guess I'll just go ahead and die," Diamond said.

When the guard went into his cell at 9 o'clock, Diamond was sleeping soundly.

Just before being strapped in the chair, Diamond said, "You men are more guilty of murder than I." Because he was in the throes of an epileptic fit, he told the warden he was not mentally responsible and therefore not guilty of the crime as charged. The warden had no reply to that comment but said that Diamond went to the chair without a falter, defiant and smiling until the clock ticked away four minutes after the hour of midnight.

Execution of Diamond Now Just Memory: Nothing at Gary Prison Indicates Friday's Episode
—*Gary Post Tribune*, Saturday November 15, 1924

The rising sun shone brightly this morning over the gray walls of the state penitentiary at Michigan City where only yesterday was gloom. Today there was little to indicate that yesterday an execution had taken place behind these walls where after midnight Thursday Harry Diamond, the convicted murderer, paid the penalty for his crime.

Diamond is dead! And with those words the most famous murder case in the history of Lake County passes into the records to become there a part of the minutes in the transpiration of human events.

Diamond is dead! He paid with his life the penalty provided by law and now he has been forgotten. It was rumored in Michigan City yesterday that unusual preparations were taken by the prison officials in preparation for the execution. A guard was stationed out about the powerhouse room where the current which killed Diamond was to come, it was said and another guard waited at the prison where the electric wires enter. It was said this precaution was taken

to prevent any attempt that might have been made to interfere with the execution. Prison officials, it was rumored, had been warned that an attempt might be made to prevent the execution but although they doubted that any such attempt would be made the extra precautions were taken as a matter of safety.

Many other newspapers reported Diamond's death as well, leading their stories with such headlines as "Slayer Dies with Grin of Indifference," "Wife Slayer: Held Hope for Last Reprieve from Governor, Does Not Deny Murder" and, in the *Indianapolis News*, "Harry Diamond Goes to His Death in Chair."

WHAT REMAINED

W.J. Murray, who had appraised Nettie's estate, tackled Harry's after his execution. On the estate docket, handwritten notes state that on October 19, 1928, an administrative file inventory and appraisal of personal property showed that Harry's asset, which was a contract of purchase of Lot 10, Block 2, Lake Shore Land Company addition to Gary, was of the estimated value of $500.

Harry, who had raked in $40,000 a year bootlegging, another $20,000 fencing stolen diamonds and who knows what profits from his roadhouse that sold illegal booze and the services of girls, had died close to broke.

Legal battles were far from over, and Harry's parents sued New York Life for double indemnity on their son's life insurance policies. On August 1, 1930, the *Vidette Messenger* reported that federal judge Woodward in Chicago on Thursday had established a precedent when he ruled that death by execution cannot be construed as accidental in an effort to collect an insurance policy. But that wasn't the end of their pursuit.

On October 10, 1931, a follow-up article appeared in the *Vidette Messenger* reporting that the United States Supreme Court had upheld the ruling of the lower courts that Harry brought death upon himself. His parents brought suit contending that Diamond's death was accidental because he was forced into it.

"Suicide is not an accident," the Seventh Circuit Court of Appeals said. "Neither is death at the hands of the law."

MEMENTO TRAGEDY IN COURT: RING TURNED
OVER TO THE ESTATE
—*Hammond Times*, Thursday, July 23, 1925

A blood stained diamond ring mutely told a story of tragedy and murder of its namesake two years ago at the outskirts of East Chicago yesterday afternoon when it was presented before the local city court to determine its rightful owner.

The ring, which has been [*sic*] worn by Mrs. Nettie Diamond on the day her husband shot and killed her on the Gary Road [*sic*], was turned over by the court yesterday to the estate of the deceased, Harry H. Diamond, represented by J.G. Allen.

It had been taken from Harry Diamond by Chief of Police Crist C. Struss of East Chicago at the time of his arrest on February 16 [*sic*], 1923 for the murder of his wife and held until court action had named the person in whose hands it should be placed. It is valued at $600.

Attorney William B. Van Horne of Indiana Harbor represented the estate.

The case was that of Mr. and Mrs. Joseph Diamond of Gary against the New York Life Insurance Company for a $10,000 policy carried by their son, Harry, who was electrocuted at the Michigan City Penitentiary for the murder of his wife, Nettie, on February 15, 1923. Diamond was convicted by a Porter County Circuit Court jury in one of the most sensational murder trials ever held in Valparaiso. Woodward held that Diamond met death because of his own felonious deed and added that though Diamond met death unwillingly, he was responsible for his execution.

THE TRAGIC BETRAYAL OF NETTIE DIAMOND

An Echo from the Electric Chair
—*Vidette Messenger*, August 8, 1931

WASHINGTON, Aug. 8.–The United States Supreme Court has been asked to decide whether death by electrocution for murder is accidental. Harry H. Diamond of Gary, Indiana took out two life insurance policies for $5,000 each from the New York Life Insurance Company. The policies contained a clause providing that the company would pay double the face value of each policy if the insured died by accident. His wife, Nettie, who had been named as beneficiary, died February 15, 1923, and he was convicted of murdering her.

He assigned the two policies to Joseph A. and Esther Diamond, and was electrocuted in the Indiana State Prison at Michigan City, Ind., on November 14, 1921. The insurance company offered to pay the face [value] of the two policies, but refused to pay double indemnity. Suit was brought against it, the beneficiaries contending that Diamond's death was from accidental causes.

The beneficiaries asserted that certain persons "against the will and over the protest and contrary to the intentions" of Diamond, had "forcibly placed him in a certain chair and by means of straps and other devices kept him in a sitting position in said chair" and "against his will, over his protest and contrary to his intention a certain other person caused a current of electricity of sufficient intensity and strength to cause death to be applied to and continued through the body of Harry H. Diamond until he was dead."

The Seventh Circuit Court of Appeals sustained the trial court in refusing double Indemnity, holding that the death at the hands of the law of one who has committed murder "is caused by his own hand

and is not an accident, and neither is death at the hands of the law." The insurance policies contained a clause that double Indemnity would not apply if the insurer's death resulted from any violation of law by the Insured.

The lower federal courts declared that provision sufficient of itself to prevent double indemnity under Diamond's policies, but in answer the beneficiaries asserted that although he was convicted and electrocuted he was Innocent of the murder of his wife.

Good News for Hiram Kerr

"In the monetary currency of Denmark, police officer Hiram Kerr of East Chicago, today is ten times a millionaire," reported the *Lake County Times* about one of the officers who arrested Harry Diamond at Calumet Drug Store on February 14, 1923.

But in the U.S. rate of exchange his newly acquired wealth would be computed at a trifle over $5000.

The big surprise came to Officer Kerr last evening when he opened a bulky special dispatched envelope and a check for $10,000.00 Danish marks fluttered to the table. "High" as he is better known among his policemen friends has battered [sic] with romance, experienced adventures with crime, faced financial difficulties and probably tussled with every other "Hard knock" in the sea of life, yet his sudden wealth thrust upon him when the whole world appeared vacant sent a shock through him equal to the of the one that took Harry Diamond away for keeps.

The check represented a legacy from a deceased uncle, Nis Kerr, who recently died in Denmark. Three others, two brothers and sister, shared in the inheritance.

After the murder, Pearl Herskovitz went to live with Anna Cohen Fishman, graduating from Washington High School and then attending college. According to Babs Maza, she married one of the founders of the Baskin and Robbins family—those of the ice cream business.

Bernard, who was born on January 30, 1913, making him three when his father died and ten when his mother was murdered, lived at the home of Sam's brother David, a resident of Indiana Harbor, as well as with Marcus and his wife, Sophie, and, at times, with Anna. Bernard was an educator and ultimately the principal of Washington Elementary in Indiana Harbor.

Lloyd, born on November 27, 1910—five and a half years before the death of his father—was twelve when his mother died. He also appears to have lived with several different relatives, as well as with Anna Cohen Fishman. He became a lawyer and also owned a

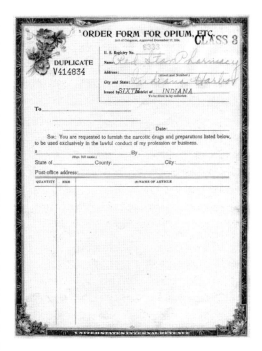

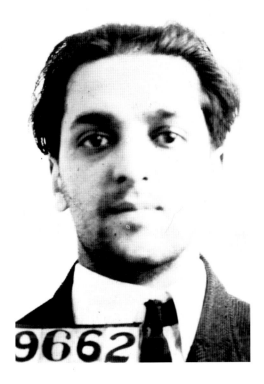

Top: Sam and Nettie owned the Red Star Pharmacy. It was legal to buy opium until the passage of the Harrison Narcotics Act in 1914. After that, doctors and pharmacists were required to pay a small registration fee to sell opioids, but anyone else had to pay a prohibitive tax on every purchase. Red Star Pharmacy could purchase and sell opium using this order form. *Photo courtesy of the East Chicago Public Library.*

Right: Harry Diamond's death row photo, taken at the state prison in Michigan City. *Photo courtesy of the Indiana State Archives.*

Lets Lawyers Battle On: Judge Adjourns Court While Attorneys Fight, Then Resumes Hearing

Hammond, Ind.

A garnishee case resolved itself into a fistic encounter in Judge Reiland's court at Indiana Harbor recently when L.W. Saric and Marcus Hershcowitz, lawyer, passed the lie. The court refused to call time. In fact, Judge Reiland adjourned court to give the belligerents all the time they wanted. They took ten minutes and then an armistice was declared and Judge Reiland went on with the trial of the case. Saric looked as though he had fought with a bearcat.

successful insurance company. Cecil, the youngest, was born on July 4, 1914, less than two years before his father would die. In 1930, the census has him living with his Aunt Etty. Like his father, Cecil became a physician, and like his father, he died young at the age of fifty. Nettie and Sam's grandchildren also achieved success—it's a family of lawyers, doctors, businesspeople, a psychotherapist and other professionals.

The baby, Gertrude Fay Diamond, went to live with Harry's parents, Joe and Esther Diamond.

Marcus Hershcowitz, Sam's older brother, had married Sophia E. Feinberg on June 11, 1907, in Manhattan, and sometime after that, the couple moved to Indiana Harbor. Marcus was frequently mentioned in the local papers for his civic activities, as well as his work as an attorney. But on October 15, 1915, the *Winslow Dispatch* in Winslow, Indiana, showed another side of his character.

On New Year's Day 1930, Marcus Herschcowitz died of a heart attack.

Etty Herskovitz Hillel, the mother of three children—Ruth, Sarah and Jack—was widowed in St. Louis and moved to Indiana Harbor, where she was listed in the Indiana Harbor phone book as a midwife. By 1930, she had married Meyer Baranowsky, a fellow Romanian (her first husband, Newman Hillel, was also Romanian) who is listed in the census for that year as a salesman and who, at age forty, was seven years younger.

THE TRAGIC BETRAYAL OF NETTIE DIAMOND

FUNERAL OF CHIEF STRUSS TOMORROW:
SERVED LOCALLY HERE FOR MANY YEARS AS CHIEF
—*Calumet News*, May 14, 1926

Crist C. Struss, chief of police under the Callahan administration, died at his home, 3821 Ivy Street shortly after 4:00 O'clock yesterday morning. Mr. Struss had been ill for the past year and death came yesterday after an unsuccessful fight against a complication of diseases.

It was announced this morning that funeral services would be held at the family home at 1:30 o'clock and 2:00 o'clock at the St. Paul's Lutheran Church.

His conduct in office was marked by a strict devotion to duty and even his political enemies praised him for the work which he accomplished.

She had enough status in the community that her comings and goings made the social page, as this *Lake County Times* write-up shows:

Mrs. Etty Baranowsky, of Euclid Avenue, returned Tuesday from Detroit, Michigan where she went last week-end to visit with her son and wife, Mr. and Mrs. Jack Hillel and her daughter and husband, Mr. and Mrs. Allen Seimin. Mrs. Baranowsky motored to Detroit with her nephew, Dr. Cecil Hurst, who came to the Twin City last week-end from his duties at the Indiana University Hospital in Indianapolis to spend a week with his brother, Lloyd Hurst, and other local relatives.

Like Sam and Nettie's children, school yearbooks indicate that all three of Etty's children were academically inclined. Jack, the youngest, was a star football player for Washington High School and also played for the East Chicago Gophers after graduation.

Etty and Baranowsky divorced, and her trail goes cold by 1940. Where her children eventually settled is not known either.

Anna Cohen Fishman had been widowed. Her first husband, and the father of her two sons, built the Auditorium Building, and the name Cohen

151

was etched into the brick. Her second husband, Morris Fishman, was not mentioned in the newspaper articles or court testimony, and he seems like a ghost of a man in that respect. He and Anna operated a restaurant/bar in the Auditorium, which had also housed one of Sam and Nettie's drugstores. The Auditorium was the place to go during Prohibition and afterward. Ardash Daronatsy, who worked for Manta and Hurst, Lloyd's insurance company, recalled that there were boxing matches on the second floor.

Anna certainly seemed to have a strong maternal nature. Her granddaughter Babs Maza has very fond memories of her and says that Pearl always kept in touch, even after marrying and moving away. As for Morris, he seems to have disappeared, and no one much missed him.

The valiant McAleer, who emigrated from Canada in 1887 when he was about twenty years of age, lost one of his daughters, who died when she was in her early twenties while visiting friends in Madison, Indiana, a lovely port town on the Ohio River. I've often wondered if his determination to ensure Harry got just what he deserved was somehow, in part, fueled by his own great loss. He had two other children, Verne and Leota. He died at age seventy-five on December 22, 1942, and his wife, Ethelia, age seventy-one, followed him less than two years later, on May 26, 1944.

Townsley the war hero and his wife, Cora Mae, did not seem to have had children. Cora Mae, born on June 6, 1882, died on September 23, 1928. The 1930 United States federal census shows Townsley living in East Chicago along with his father, James, age seventy-eight, and mother, Margaret, age seventy-four. He died four years later on April 10, 1934, at age fifty-six and was buried at Oak Hill Cemetery in Hammond next to his wife. His life was shorter than it should have been.

There are references in court documents that James H. Allen, the vice-president of the Indiana Harbor National Bank who was guardian of Nettie's estate, died in a train accident around 1926 or 1927.

William Murray went on to become a long-serving judge in Lake County.

Charles Webb Yarrington and his wife, Bessie, had two sons—Charles Webb Jr., who was born on June 6, 1908, graduated from the University of Michigan with a bachelor of science in 1930 and then entered the university's medical school, and Edouard Bancroft, who was born on September 28, 1910, graduated from Emerson High School and also attended the University of Michigan.

As for Noah Zauderer, a rather cryptic charge on Matthews's bill submitted to Nettie's estate contains charges for an emergency trip to St. Louis. Did the emergency trip have something to do with Noah?

Nettie always said she was born in New York. When she was divorcing Zauderer, the newspaper mentions that her mother, Mary Sachs, and son Edward Sachs were living with her in St. Louis, though they don't mention Noah, her son by Zauderer. By the time of her death, her mother was living in New York again, according to newspaper accounts, and was too ill to attend her daughter's funeral.

In the thousands of newspaper clippings I've read and reread, I have never found the name of Nettie's father or her siblings. The latter did not seem to play a significant part in her later life and aren't reported as attending her funeral or the trial.

Nettie's bullet-ridden fur coat never reappeared. As for the Smith and Wesson .32 with the broken grip caused by the beatings bestowed on Armstrong and Nettie, it, too, seems to have been lost. I was told by a policeman in East Chicago that many items from the murder most likely were taken as souvenirs over the years. But the Hudson with its busted-out passenger door window and blood-spattered seats was sold by the estate to John Bucnowski in 1923.

William Armstrong, born in 1905, seems to have remained in Gary through much of his life. Social Security death records show that he died in 1970. Thanks to his ability to overpower Harry and the kindness of the truck driver stopping to help, he earned fifty-five more years of life and kept Harry from getting away with murder. I hope he had a wonderful life; he deserved it.

As for Nettie, even now she eludes me. She first walked onto the stage in 1902, when she married Louis Joshua Zauderer, and over the next twenty-one years the chronology of her life can be traced, not in full, but somewhat. Where she was before that, I still don't know. Other things I don't know: Her birth, her upbringing, what happened to her sons Noah and Edward and her real age. Her mysteriousness makes me wonder how well her husbands knew her. We do know that she exited the stage on February 15, 1923, but not until she had told the story of the end of her life. Maybe someday I'll learn the beginning.

BIBLIOGRAPHY

Calumet News, 1926.

Chicago Tribune, 1923–24.

East Chicago Anvil, 1925.

Gary Post Tribune, 1923–24.

Howat, William F., ed. *A Standard History of Lake County, Indiana and the Calumet Region*. 2 vols. Chicago: Lewis Publishing Company, 1915.

Indianapolis News, 1923–24.

Indianapolis Star, 1923–24.

Indiana State Supreme Court Trial Transcript.

McKinlay, Archibald. *Twin City: A Pictorial History of East Chicago*. Norfolk, VA: Donning Company, n.d.

Moore, Powell A. *The Calumet Region: Indiana's Last Frontier*. Indianapolis: Indiana Historical Bureau, 1959.

Pendley, Trent D. *Indiana Jewish History: The Jewish History of the Indiana Dunes Country, 1830–1950.* N.p.: Indiana Jewish Historical Society, n.d.

Pharmaceutical Era 40 (1908).

St. Louis Post-Dispatch, 1908–09.

Times (also titled *Lake County Times, Indiana Harbor Times* and *Hammond Times*), 1910–32.

Valparaiso Evening Messenger, 1923–24.

Vidette Messenger, 1923–32.

Wimmer, Curt P. *A History of the College of Pharmacy of the City of New York Included in Columbia University, 1904.* N.p.: Google eBook, 1929.

Winslow Dispatch, 1915.

Numerous documents at the East Chicago Room, East Chicago Main Library and on microfilm at the Lake County Superior Court were also consulted.

INDEX

INDEX

ABOUT THE AUTHOR

Jane Simon Ammeson is a writer specializing in history, food, travel and personalities. Her work has appeared in national and international magazines, and she has written numerous Arcadia books, including *Holiday World*, *Miller Beach* and *Brown County*. She was born and raised in Indiana Harbor and became interested in the story of Nettie and Harry Diamond when she learned that many of the people she knew when growing up had connections to this quintessential Jazz Age story.